THE
WITCH *of* DELRAY

ROSE VERES
&
*Detroit's Infamous
1930s Murder Mystery*

KAREN DYBIS

D0916620

THE
History
PRESS

Published by The History Press
Charleston, SC
www.historypress.net

Front cover, left: author's collection; *right*: author's collection; *bottom*: courtesy of the Library of Congress.
Back cover: author's collection.

First published 2017

Manufactured in the United States

ISBN 9781467137546

Library of Congress Control Number: 2017945016

Notice: The information in this book is true and complete to the best of our knowledge. It is offered without guarantee on the part of the author or The History Press. The author and The History Press disclaim all liability in connection with the use of this book.

For Pete and Robin, so you may understand what Theodore Roosevelt meant when he said, "Justice consists not in being neutral between right and wrong, but in finding out the right and upholding it, wherever found, against the wrong."

CONTENTS

ACKNOWLEDGEMENTS

Thank you to the Archives of Michigan and the Burton Historical Collection of the Detroit Public Library for providing a wealth of information for this book. Thank you to the families of John O. Whitman and Alean B. Clutts for their help with stories and photographs. Thank you as well to my family and friends for finding Rose, guiding me as I researched her story and listening as I tried to unravel her legal case.

This is a work of nonfiction. All quotes used in this book came directly from a newspaper, affidavit or court transcript. Certain words used in these quotes may affect modern sensitivities. But, after much thought, I have chosen to retain these words because they are historically accurate.

1
THE FALL

Detective John Whitman's eyes narrowed against the August sun as he traced the body's fall to the Detroit dirt, imagining it ricocheting from the attic window to the neighbor's clapboard siding to its final resting place on the muddy ground.

Whitman took an inventory of the alley before him. Two rundown bungalows. An open window. A ladder leaning against one of the houses. Tools and a toolbox scattered in the wet soil.

It was clear that Steve Mak's body had hit the ground with force. An ambulance took Mak to Receiving Hospital, but Whitman would be surprised if the poor soul survived the night.

Whitman, conscious of his polished oxfords sinking into the turf, moved to the sidewalk. Nothing else seemed out of place in this typical Delray neighborhood, where each building was so close you could whisper in one room and someone next door would hear it.

He pulled a white handkerchief from his suit and swept the sweat from his broad forehead. The street was quiet—for now. That gave Whitman time to think.

Some in the homicide department might question why he brought the busy squad to what looked like a handyman's clumsy tumble. But the veteran lawman sensed this wasn't just another case. When the call came in, Whitman knew the Witch of Delray was at it again.

Someone, perhaps a neighbor, had been watching and waiting for this opportunity. A mysterious voice alerted police to another incident at 7894

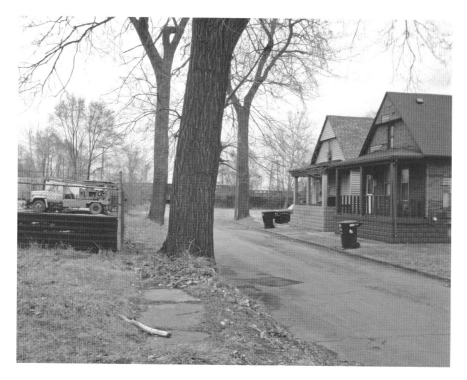

Medina Street is a closed-off block near Jefferson Avenue in Detroit; Rose's house would have been between the two trees. *Author's collection.*

Medina Street. How many deaths had there been? Seven? Ten? Whitman lost count.

Whitman scanned the approaching crowd. His gaze found Rose Veres, wearing a shapeless black dress and her customary knit cap. Her eyes met his, and he was once again struck by how their blue-gray color looked right through you. Some believed she had the power to hypnotize. Frightened neighbors gave Rose the nickname "The Witch of Delray," and it stuck.

In his seventeen years on the force, Whitman had worked some of Detroit's worst crimes. Domestic battles where lovers turned killers. Murderous arguments between territorial bootleggers. Gang warfare that left dozens dead. Whitman could walk away unaffected.

The cases that bothered him were the unsolved ones, like the Witch. Rumors about her had circulated in Delray for years. Neighbors claimed the Witch of Delray controlled the neighborhood, terrorizing men, women and children. Mak might be the latest victim, which meant Whitman had to secure the scene and fast.

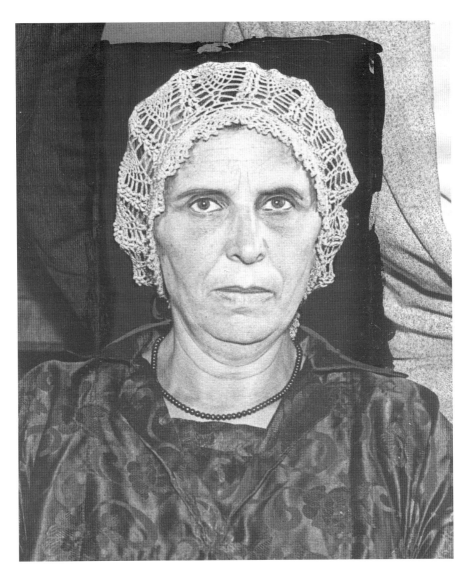

Rose Veres was known in her Delray neighborhood for keeping a tight leash on her boarders, treating them like her own children. *Author's collection.*

Detroit Police had made their share of runs to the Veres boardinghouse over the years. Sometimes, it was to drag her sons home or to calm an angry drunk. More often, it was to handle a death. There always was an answer as to why man after man expired unexpectedly. Pneumonia, suicide, heart attack, alcoholism. Boarders walked in but left in pine boxes.

Rose and her husband, Gabor, had opened their home to boarders years before as a way to make ends meet. Men, eager for good-paying factory jobs, had flooded Detroit. Running a *burdoshazak* was honorable—if a man needed a bed and a family needed extra income, it makes sense to put him up. Going on the dole to pay your bills was shameful, even in Detroit's Great Depression.

The Witch had been arrested once in 1925 after two boarders died under suspicious circumstances. No evidence was found, and no accusation could stick. Apprehensive neighbors claimed they were too afraid of the Witch to speak against her. She left police headquarters a free woman.

Gabor died in 1927, leaving Rose to run the boardinghouse alone. One cold January night, Gabor had closed himself in the garage to fix the family car, hoping to save the family a few dollars. He had succumbed to monoxide poisoning along with one of his friends. Neighbors whispered it was no accident, suspecting Rose had silently shuttered the door.

As a widow, Rose wore black as she went about her daily chores. She was a mother with three mouths to feed, clothe and get to school when they weren't skipping it. She also was a business owner, getting up at 4:00 a.m. to get the men to work, washing clothes all day, fixing meals and cleaning until late at night.

Police kept tabs on Rose as well as her oldest son. Bill Veres, who had just turned eighteen, had been caught recently stealing from a neighborhood store. He was a skinny kid, standing only a few inches taller than his mother. He hovered around Rose like a dog, staying close to her elbow. Her other sons, ages fifteen and twelve, followed Bill's lead. Bill, being the man of the house, may know more than he would like to admit, Whitman thought. Bill might need an alibi, and Whitman knew the sooner the police separated the brothers from their mother, the better.

Whitman turned his eyes back to Rose's small bungalow. The question was how Mak, a well-known neighborhood figure, could end up face-first in the mud. Stepping carefully across the cracked pavement, Whitman knew the next step was rounding up witnesses. That was easier said than done—Delray wasn't the kind of neighborhood where people willingly talked to police.

People kept to themselves in Hunkytown, Detroit's nickname for the area and its huge Hungarian population. Located a few miles from the city center, Delray's riverfront location, salt mines and strong backs attracted factories and families of all kinds. It was a blue-collar neighborhood, the kind of place that worked hard and played harder.

John Whitman was considered one of Detroit's top cops, serving as a lieutenant within the detectives' bureau. *Whitman family collection.*

Men rose early to work at Solvay, American Brass or Detroit Edison. They came home physically exhausted, only to do it all over again after a few hours' sleep. Women kept house, swept the walks, watched the children and managed to get food on the table. Weekends centered on the church or the synagogue, passing bottles of homemade wine and taking pleasure in small diversions.

Delray was their home away from home. They came from the Old Country, and they took comfort in living next to like-minded people. There was solidarity within their comfortable isolation. In Delray, no one cared if you spoke only your native language. You could make do.

But life was changing. Armenians, Poles, Italians and blacks were moving into Delray just as fast as the old families moved out. People who were Rose's trusted neighbors headed north of Fort Street, leaving the colony behind. Life was moving faster than a Ford assembly line. And, like Henry Ford, people wanted immigrants to assimilate: they had to learn English, dress like Americans and become part of the city's melting pot.

As news of Mak's fall spread, witnesses were clamoring to tell how Mak came crashing from on high, flailing as he fell like a flightless dodo. It wasn't natural, they said. They met in small groups, talking quietly among themselves while they waited on Whitman.

A respected supervisor on the detective's squad, Whitman's name came up frequently on the radio and in newspapers. The lieutenant's combination of

Many of Henry Ford's employees, along with those of other factories, were immigrants. They were forced to take classes to learn English and to blend into the U.S. "melting pot." *Courtesy of the Library of Congress.*

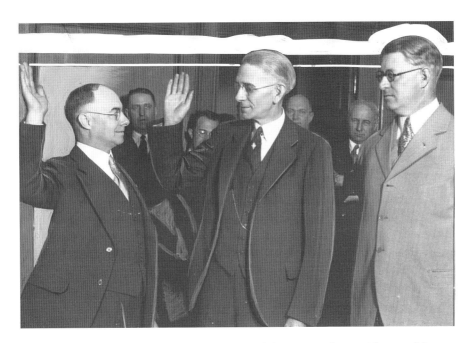

Mayor Charles Bowles (*right*) was Detroit's fifty-eighth mayor and, arguably, one of its most controversial. Here, Bowles supervises as Detroit city clerk Richard W. Reading (*left*) swears in Thomas Wilcox as Wayne County sheriff. *Author's collection*.

common sense and intuition made him an asset to the force and to the local newspapers. With a voice like a grinding cement mixer, Whitman always had a minute for waiting reporters, giving them an insight or a witty phrase to please any demanding editor. For the public, his word became law. Seeing Whitman in his flattened hat squarely on his head raised the community's confidence in a city struggling with crime.

At this moment, however, Whitman held his hat in his hand, hoping for a cool breeze to pass through. He stepped into what little shade he could find. The warmth mixed with the horde outside the Witch's home didn't sit right with him. The potent chemistry of Medina Street, Mak's mysterious fall and suspicious murmurs made the air seem heavy. For a moment, Whitman indulged himself, closing his eyes to picture that same Sunday afternoon at home. His wife and daughter were likely in the garden. Maybe they were watering the flowers, tending to his gladiolas in this heat. How he longed to be with them.

His job pulled him away time and again. More than halfway through 1931, and Whitman felt like he still didn't have his bearings. How could you, when you patrolled a city of contrasts, pitting society's haves against

the have-nots? The Crosstown Mob Wars had unleashed the Eastside and the Westside, leaving bodies in its wake. Auto barons hired and fired at will, dominating their workforces like an angry father swinging a belt. Factory layoffs put thousands of desperate men on the street. Illegal gambling was widespread. Despite Prohibition, drinking and importing alcohol was so rampant Detroit became known as Whiskeytown.

Whitman, happy for his job, felt the cold shame of hungry men. Relief agencies were pushed beyond their capacity. Everyone was worried. Full-page ads in the newspapers talked about life insurance as "a necessary form of protection. No man can afford to neglect it."

The police department was struggling as well. Detroit mayor Charles Bowles, already controversial for having the support of the Ku Klux Klan, had turned a blind eye to underworld killing sprees. "Perhaps it is just as well to let these [gangsters] kill each other off, if they are so minded," the mayor had said. Voters finally recalled Bowles, a relief to officers like Whitman who tried to keep their nose clean.

The bloodshed that tarnished his birthplace grieved Whitman, and he felt powerless to stop it. Whitman was raised in Detroit, the eighth of nine

The fraternity of Detroit police was strong, as officers faced regular danger from an increasingly mobile population. *Author's collection.*

children born to German immigrants. He had wooed his wife, Carrie, while strolling Belle Isle and boating on the Detroit River. Together, they were raising her daughter Aurelia, now eleven years old and sweeter than a rose. He tried to shelter them from the city's sense of lawlessness.

In his years on the force, Whitman watched Detroit grow from a minor port to a metropolis. It was the fourth-largest city in the United States with a population topping 1.5 million. And it had the crime, corruption and disenfranchised population to show for it. It was a city of strangers; it seemed every other person was an immigrant with a family to feed. Racial tensions were growing with the influx of southern workers into neighborhoods like Delray, Black Bottom and Paradise Valley. Rather than fix the mess, the city's mayors were weak, beset by illness or greed, taking advantage of new investment to line their own pockets. The police were considered powerless, incompetent or corrupt. And the newspapers had grown fat off the public's interest in stories of self-indulgence and delinquency.

Enough was enough.

Did she do it? Did Rose Veres push Steve Mak in hopes of killing him? Why? Had Detroit, with its big factories, big personalities and big problems, become so depraved that human life meant nothing?

Whitman took off his suit coat and rolled up his sleeves. Time to get to work.

✦

THE ARREST

Whitman and his partner were the first to visit Mak at Receiving Hospital. Bruised and woozy, Mak looked every bit of his forty-seven years. Whitman noticed Mak's undershirt, sodden with sweat and filth, had taken on a pinkish hue as blood dripped from the cuts on his head. At five feet, three inches tall and 155 pounds, Mak was a fireplug, powerfully built from years of factory work. Yet drink and hard living had taken its toll.

Notebook out, Whitman ran through the usual questions. In broken English, Mak mumbled about having no job but looking for work. That didn't surprise Whitman; most of Detroit was unemployed. Whitman asked Mak where he lived, and Mak gave his address as Medina Street, saying he had a bed in the house of a widow lady named Rose Veres.

Rose had asked him to fix a window that morning. Even if he hadn't felt like it, Mak agreed to do it. He owed her money, and she got angry if you didn't help out around the house. Mak heaved a sigh as his massive head slumped, as if the weight of his injuries had caught up with him.

Whitman turned to his partner.

"Now we've got a lead," Whitman said. "Maybe we've got the Witch at last."

It was the last time Whitman talked to Mak, a widower who came to the United States to make money to help his three daughters. Mak died on August 25, 1931, two days after his initial injuries. He was alone when he breathed his last; his children in Hungary learned of his death months later.

All he had left was life insurance. The policies came from one of the many door-to-door insurance agents who frequented Delray. When Mak couldn't

John Whitman (*left*) became the lead detective on the Rose Veres case, organizing the investigation on Medina Street. *Whitman family collection.*

afford to pay the bill in recent years, the policy's beneficiary always had a dime or two to help him.

The beneficiary? According to neighbors, it was Rose Veres.

The insurance policies had popped up unexpectedly. Whitman had taken advantage of those precious first hours, getting as much done at the Veres

house as possible. When they got the go-ahead, police searched Rose's half of the duplex from top to bottom, getting the kind of access previous visits did not allow. The family's possessions, limited as they were, drew little attention until officers reached Rose's bedroom. There, a well-used trunk revealed neat piles of paperwork that appeared to be insurance policies and a notebook full of Rose's spidery handwriting. Whitman knew these papers needed a complete review, so off they went to headquarters.

Watching police carry out handfuls of correspondence looked interesting to the seasoned newspaper reporters now gathering at the scene. Delray turned up an ink-worthy story on a regular basis, so it had its share of informants. Hanging out at the bars and restaurants that dotted the area filled a reporter's stomach and his notebook as well. And a full notebook made for a happy editor. A few questions whispered to their favorite officer got the intended result: It seemed Rose Veres had insurance policies on the men who took up residence in her house. With as many as twelve deaths at that address alone, it meant the insurance money was flowing.

The *Detroit Free Press* shouted the sensational story. Its headline on August 26, 1931, had a typeface larger than the ones used to announce Charles

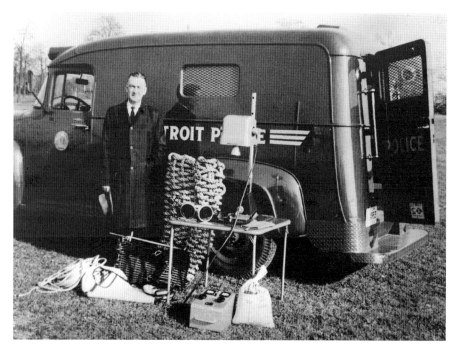

Detroit police had a mobile crime lab that could help them process evidence while they were on a crime scene. *Author's collection.*

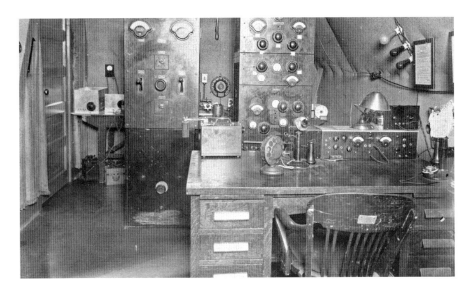

Detroit police stayed organized and one step ahead of criminals with technological advances like radio systems. *Author's collection.*

Lindbergh crossing the ocean. In fact, word of the suspected slaying of Rose's lodger trumped updates on President Herbert Hoover, Governor Franklin D. Roosevelt and Cornelius Vanderbilt Jr. "Woman Held for Murder," the headline read. "10 Men Missing. Fate of 3 Husbands, Others in House to Be Probed." In an era when crime news dominated the front page, the idea that a female mass murderer might be lurking in Detroit likely sold many a three-cent newspaper.

Like ants on an anthill, Medina Street soon was covered with reporters. Vera Brown was the most dogged among them. Vera stood out with her sharp features and signature felt hat. Not content to write recipes or cover the social scene, the town's best-known sob sister had a knack for finding the big story of the day. Brown knew she had to move and talk faster than her fellow male reporters. Police and public officials gave her a wide berth, worried her dangling cigarette might burn them in more ways than one.

Brown had found a home at the *Detroit Times*, the city's fastest-growing newspaper due to the deep pockets of owner William Randolph Hearst. Because of Hearst's wire service, newspapers across the United States carried Brown's stories about the Witch of Delray on their front pages. People from Texas, Pennsylvania and Indiana saw her byline splashed across the newspaper and absorbed every word.

"Cold blue eyes, a deeply lined face, a silent tongue!" screamed Brown's first dispatch. "Mrs. Veres is known as the 'witch lady' by the neighbors who stand in groups on the sidewalks and in the street before the house where the police say Mrs. Veres pushed Steven Mak, her tenth alleged victim, out of an attic window to his death."

Police set up a press conference. Whitman told reporters multiple men had passed away while living in Rose's house. Two lodgers, one in 1924 and another in 1925, were said to have died suspiciously. Pressed for details, Whitman stuck to the facts. "Post-mortems were held in both cases," Whitman said, his speech slow and steady. "We had been told that poison had been placed in their liquor. The post-mortems failed to substantiate the claim."

At police headquarters, officers began to scrutinize Rose's stockpile of insurance policies. There were nearly seventy-five altogether, neatly kept in account books: canceled policies, current paperwork and information that might help Rose make a claim when the time came. Altogether, newspapers reported police found six policies on Mak from three separate companies.

Whitman demanded field officers continue to ask questions. One interesting lead came back. A neighbor named John Walker told officers he thought there was a policy valued at $4,000 somewhere on the property. Although police combed Rose's rooms, it had yet to be found. Whitman ordered the search to continue. Follow the paperwork, he believed, and the rest of the case would fall into place.

Not content to wait for leads, reporters did some investigating of their own. To find out more about the Witch, they interrogated the people who lived and worked on Medina Street. They started with the people who served the community the most: funeral-home directors and insurance salesmen. These professionals had multiple exchanges with Rose and her boarders, and they knew their day-to-day routines.

The *Free Press* had a scoop with insurance salesman Eugene Newman, who had called on Rose's house in the weeks before Mak's death. He had come by six or seven times, Newman said, to sell insurance policies to the men who lived there. These men were single, far from home and, typically, strongly tied to the traditions of their homelands. That meant having an insurance policy to cover their death expenses. It was part of your masculine responsibilities. Rose's boarders were good customers; Newman said he wrote a $2,500 policy on Mak's life in 1929, payable to Rose.

"They were always too sodden with drink to appear able to work," Newman said. "Mak, as far as I know, had not worked in four years and

John Whitman joined the Detroit police force in June 1914, slowly rising in rank to become a detective and then a lieutenant in May 1929. *Author's collection.*

was supported by Mrs. Veres. One day when I called about a policy, I found Mak groaning in the basement, where he was sitting on his cot in a drunken stupor."

Rose met the premiums all right, Newman said, but John Hancock Mutual Insurance had canceled the policy. Newman said Rose was furious about the cancellation, and she shared her frustrations.

Detroit police detectives, dressed in their customary suits and overcoats, prepare to head to a crime scene. *Author's collection.*

"Mrs. Veres was very angry. She asked me to get her a new one, promising to pay me well if I was successful. She didn't get the policy, but I understand she got one later for $186," Newman said.

With a motive in place, Rose and Bill were arrested. They were taken to the Wayne County Jail, where they would sit until their trial.

Whitman turned over what he had to prosecutor Harry S. Toy. Whitman respected Toy, voted the county's top lawyer in 1930. Toy promised in campaign speeches to shelter the innocent and condemn the guilty. "It is not only the duty of the prosecuting attorney to convict the known criminal, by resorting to every means possible, but it is his duty to protect the innocent who have been accused of wrongdoing," Toy said. The prosecutor "must protect the oppressed and those wrongly accused of crime. And let me assure you, my friend, that if I become convinced that a person accused of a crime is really innocent I should not hesitate to move for the dismissal of the charge against him, regardless of public sentiment."

Big-chested and bald as a cue ball, Toy was known for being honest and tough on corruption. Toy promised to clean up Detroit's seedy reputation, and that meant going after gangsters, rumrunners and murderers. The whole city was put on notice. Toy's crime-busting efforts earned him the nickname "Headline Harry" from friends and foes alike.

Toy was finishing one of the city's largest murder trials—the shocking shooting death of popular Detroit radio personality Gerald Buckley—when

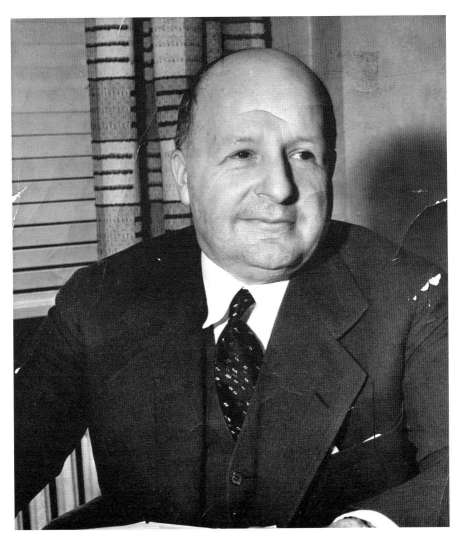

As Wayne County prosecutor, Harry S. Toy promised to clean up Detroit's crime-ridden areas and put an end to the lawlessness that seemed rampant across the city. *Author's collection.*

Rose's case broke. Mobsters had shot Buckley in the Hotel LaSalle lobby on the night of the mayor's recall election as revenge for his outspoken opposition to Bowles. The Buckley case was exhausting; Toy even collapsed in court once. The public and the newspapers wanted a conviction. Buckley had died, the *Detroit Free Press* wrote, "because the government of the city of Detroit failed to maintain a decent check on banditry and gunmen, but

allowed them to think that the town is wide open and 'easy.' His blood cries from the ground for vengeance."

His hands full, Toy assigned two of his top men to the Mak case. Toy had put together an office of young and aggressive prosecutors. George M. Stutz and Duncan C. McCrea were polar opposites, yet Toy was intrigued to see how they would work together. For Stutz, it was his first big trial as a new assistant prosecutor. For McCrea, it was a chance to get some much-needed ink in an election season.

McCrea, who had his eye on a vacancy for a judge in the recorder's court, had been a part of the Wayne County prosecutor's office since 1925. Word was, Toy was happy to have his experience on board. Toy's campaign, which some considered a smear on Detroit, left a bitter taste in the mouths of the previous prosecutor's attorneys. Most of those men followed up on their threat to walk off the job when Toy came into office. As a result, Toy had to build his staff from scratch. Something about McCrea—maybe his outgoing personality and his seemingly endless connections—caught Toy's attention. Soon enough, McCrea had positioned himself as Toy's right-hand man.

Appointed at twenty-seven, Stutz was one of the youngest assistant prosecutors. Everyone thought Toy had taken a risk when he appointed such a greenhorn. But Stutz's pedigree and unlimited potential was a natural fit for Toy's ambitions. Toy appreciated the ethics and empathy of his fellow Detroit College of Law graduate. Stutz, known for his full head of hair and kind eyes, was a Jewish immigrant whose family had to flee Europe after the family business burned down; anti-Semitic arsonists were suspected in the blaze. Stutz became known as a community crusader when he helped organize Detroit's Emergency Relief Fund for people suffering during the Great Depression. Plus, Toy knew Stutz was the kind of fellow who followed every rule and regulation, making him an ideal assistant prosecutor.

Rose's attorney fit somewhere in between. Frank M. Kenney Jr. had dreamed of being a successful defense attorney since he passed the bar in 1927. But he was still struggling to earn a reputation in recorder's court and in Detroit's legal circles. In fact, the only time Kenney made the newspaper before he was hired to defend Bill and Rose is when he threw a controversial beer party to thank jurors on one of his cases. Feeling confident the Veres case could be his big break, Kenney was eager to take on the biggest trial of his career. Kenney, eager for attention, told reporters the charges against his clients were "ridiculous" and no more than "a neighbors' quarrel."

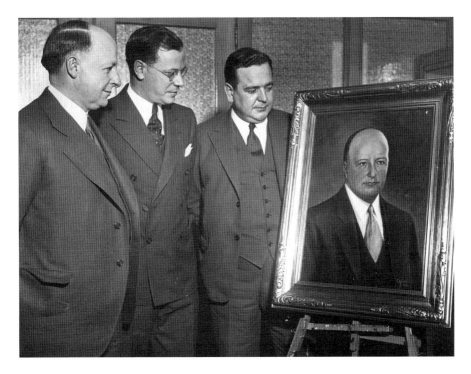

Assistant prosecutors join Harry Toy as an artist unveils his portrait as part of his new role within the prosecutor's office. *Author's collection.*

Yet there was little Kenney could do to stop the flow of information pouring into officials' ears. Rose's neighbors had gone to police headquarters to express their fear of Mrs. Veres if she should be released. They were apprehensive of Rose, despite the fact she had been taken into custody. She had told them she was above prosecution, they claimed, and she likely would seek revenge when she returned.

The prosecutor's investigators searched for additional witnesses. A child claimed she saw Rose run out of her house after Mak fell, cobwebs in her hair. A neighbor said Rose asked to wash her face and hands in her sink, perhaps to remove evidence of her deeds. The biggest wealth of information came from a newcomer, an African American man named John Walker. He was one of the few neighbors who seemed to show no fear of the "witch woman" or her alleged powers.

Walker, whose family shared the thin walls of Rose's duplex, had intimate details of Rose's activities in the hours leading up to Mak's fall. Walker said he had heard noises in his attic, and he found Rose there when he looked

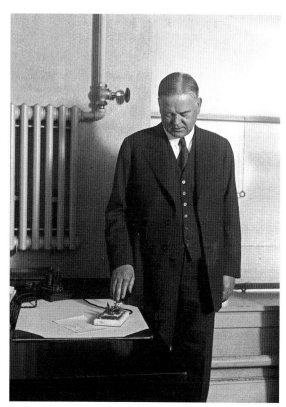

Left: Many scholars blame President Herbert Hoover's inaction for allowing Detroit and the rest of the nation to slip into an economic depression. *Courtesy of The Library of Congress*.

Below: Detroit police were busier than ever in the late 1920 and early 1930s as Prohibition brought a sizable rumrunning business into the city. *Author's collection*.

into the space. Rose, Walker claimed, was sawing a passage through the attic partition the day before Mak allegedly fell from the ladder outside Rose's second-story window. "She said she was fixing an electric light," Walker explained.

Police and prosecutors questioned Rose with this new information, trying to start a timeline of where she was in connection with Mak's death. But all questions were met with Rose's blank stare. Police kept Rose's sons Bill and Gabriel away from Rose during her stay at police headquarters, refusing to allow them to speak to her in Hungarian.

THE WOMAN KNOWN as "Rose Veres" began life as Rozalia Sebestyen in Sarud, Hungary. Born on December 26, 1877, Rozalia was the daughter of Janos "John" Sebestyen and Rozalia "Rose" Bolyhos. Her birthplace was said to be a small village, and Rose's life there would have focused on family, church and household chores.

Around age twenty-five, Rose became a wife. She married Marton Csorgo on October 25, 1902, in Sarud. Three years after their marriage, Marton left for the United States. Passenger lists show he arrived in New York on September 11, 1905. His final destination was listed as Delray, Detroit. The 1910 U.S. Census lists a man now named Martin Csorgo as a single white male, a laborer at the Solvay Processing Plant and a boarder in a home on Barnes Street in Detroit.

Rose left Hungary in 1912 for the United States. Her ship passage lists her final destination as Delray, where she hoped to reunite with Martin. But the reunion did not go as planned. Martin and Rose were said to have divorced shortly thereafter.

Some time later, Rose met Gabor Verisch. They were wed on November 8, 1916, when Gabor was twenty-six years old. At least one record puts the bride's age as thirty-two years old with a birth year of 1884. Marriage records list her name as "Rosie," perhaps a nickname Gabor had for her. On his 1917 draft card, Gabor lists his hometown as Agaefonios, Hungary, and his occupation as a laborer at the Solvay Processing Plant. The card's description calls him short with a medium build, blue eyes and brown hair.

The 1920 census showed the couple had three sons. William, the oldest, was born in 1914. Gabor or Gabriel was born on December 7, 1915. A daughter, Elizabeth, was born on July 14, 1917, but she died as an infant on August 15, 1917. She is listed as buried at Holy Cross Cemetery. A fourth child, John L. "Louis" Veres, was born on January 19, 1919.

Rose Veres emigrated from Hungary to the United States to follow her husband, who had abandoned her to move to Detroit. *Author's collection.*

In the 1930 U.S. Census, Rose is listed as the homeowner at 7894 Medina, and the home's value is $14,500. The home's occupants include Steve Mak, an immigrant from Budapest, Hungary. Census takers listed his profession as a laborer doing odd jobs.

IN RECORDER'S COURT on August 29, Kenney asked for a hearing to determine whether formal charges would be filed against Rose and Bill. Mother and son had been in police custody since Tuesday, when Mak died. Kenney wanted them released. Rose and Bill sat quietly by their attorney, who seemed to be growing redder by the minute.

Kenney complained to Judge Henry S. Sweeny that McCrea and Stutz were keeping him away from Rose. Kenney alleged the police had beaten Rose in the hopes of getting a confession. The defense attorney asked Judge Sweeny to transfer Rose to the sheriff's department for her own protection.

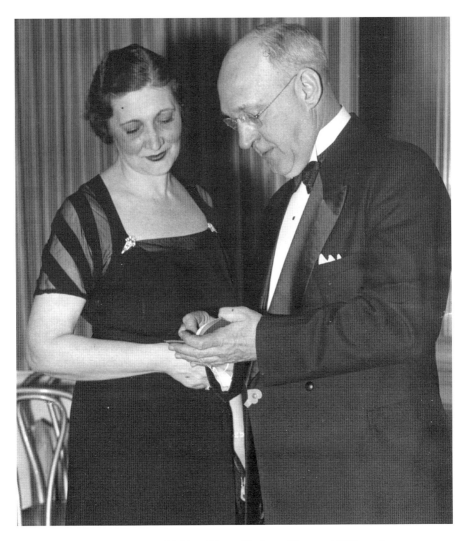

Judge Henry S. Sweeny (seen with his wife) presided over Rose and Bill's arraignment. *Author's collection.*

"Mr. McCrea and Mr. Stutz in company with three policemen were questioning Mrs. Veres and as soon as the two prosecutors left the room, Mrs. Veres was beaten, kicked, choked and slapped," Kenney said.

Judsge Sweeny seemed unmoved. "I take little stock in these stories of so-called beatings," the judge said. "But undoubtedly there is some of it going on. I would have extended the writ indefinitely anyhow and I dislike to distinguish between the sheriff's office and the police department."

Stutz denied the beating charges. Stutz told the court if there had been any assault, it was on the police and himself by the defendant. Whenever she was questioned, he said, Rose would stare in her questioners' faces. He said she apparently believed she had a power to influence people. Stutz added she believed herself "superior to mortals."

"She thinks she has a hypnotic eye, Judge," Stutz explained. "In fact, she frightens all of us when she stares at us."

Stutz met with the press. The prosecutor's office would pursue first-degree murder charges against Rose and Bill. Stutz told reporters more than one hundred witnesses had been questioned. Many centered on Rose's insurance policies on her boarders and how she cashed in after their deaths. Those insurance policies played an important role in the prosecutor's decision, Stutz said.

Tuesday morning, Stutz called another press conference at his office. Something big was breaking, and everyone had their pencils hovering over their notebooks. What was the story?

Stutz hesitated, blindsided by the noise and flashbulbs. When he finally spoke, his words had the explosive power the prosecutor's office wanted.

The Witch, he said, had confessed.

3
THE CONFESSION

Whitman usually welcomed thunderstorms. Rain and lightning fought the grime and odors of Detroit's heavy industry. In Delray, a downpour temporarily cleared the haze that hovered over the neighborhood. The ozone-heavy air also helped bring Whitman's garden to life, drawing everything toward the sky. But this September morning felt dark well beyond the clouds above.

Whitman spread the local newspapers across his desk. "Witch Widow Admits Murder"; "Landlady Said to Admit Only One of 12 Murder Charges"; "Mrs. Veres and Son Held without Bail as Slayers."

Sometime during what the prosecutor's office described as one hundred hours of grilling, Rose Veres supposedly confessed to Steve Mak's murder. It came as a shocking end to the investigation, Whitman thought. The last time he had seen Stutz and McCrea was on Thursday, when Whitman had answered their questions as they completed a secondary search of Rose's bungalow. Now, the two assistant prosecutors claimed they had everything tied up.

McCrea told reporters Rose had admitted killing Mak to a friend; yet the prosecutor's office would not reveal the name. McCrea also declined to say the circumstances under which the confession was obtained.

According to McCrea, Rose confessed she was hard up for money and needed the insurance payout. She tried to poison Mak by putting lye in his coffee and liquor. But when she found he was "not dying fast enough," she

lured Mak up the ladder propped against her home, urged him to enter the attic window and then pushed him out to his eventual death. McCrea said Rose insisted Bill wasn't there when she sent Mak flying. However, McCrea didn't believe Rose could have pushed such a huge man from the window herself. McCrea conceded that he had been unable to make Rose admit causing any of the eleven deaths that supposedly preceded Mak's in the years she ran a boardinghouse in the cellar of her home.

"We will not reveal the identity of the person to whom she confessed until he takes the stand during the woman's trial," McCrea told the *Detroit Times*. "However, it is an open-and-shut confession. She said she pushed him when two poison attempts failed."

Stutz seemed confident the prosecutor's office had what they needed to convict Rose and Bill. Stutz and McCrea also told reporters they believed Rose pretended not to speak English. Stutz called her "a woman of iron."

Along with documents charging Rose and Bill Veres with first-degree murder, Stutz and McCrea now had a warrant out for the arrest of two additional men, "John Doe" and "Richard Roe." The two were said to be

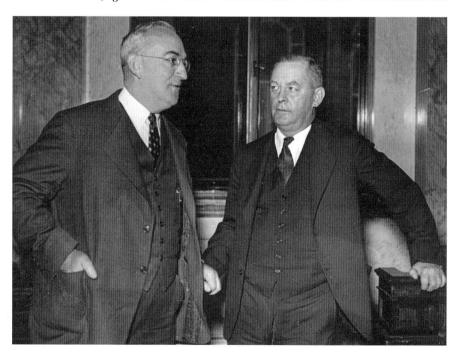

Duncan C. McCrea (*left*) was one of the assistant prosecutors assigned to the Rose and Bill Veres trial. He soon took over the majority of the prosecution in the case. *Author's collection.*

among the sixteen lodgers who had stayed at the Veres house over the years. They supposedly were the men who tried to force poison down Mak's throat twice, McCrea said. Now they were missing, having fled after Mak's death. Stutz added that the authorities would conduct another wholesale roundup in Delray—they'd interview another one hundred witnesses if they had to—to find those two accomplices.

One final paragraph caught Whitman's eye. Deputy Coroner George L. Berg told the *Detroit Free Press* he saw "nothing unusual in 10 men dying in a transient rooming house during eight years." Neither, he said, was it unusual for foreigners, living in almost native surroundings, to have their landladies insure them for burial expenses in case their time comes while on her bounty. There were even stories from neighbors that insurance salesmen sometimes covered the bill for a time if a customer was late on payment, making sure the money got in and their own records were straight.

Back in Recorder's Court, the prosecution asked Judge Sweeny to arraign Bill and Rose on charges of first-degree murder. After they were brought in, Whitman tried to make out what Rose and Bill were saying to each another. But he couldn't understand a word; it was all in Hungarian.

As soon as the hearing began, a visibly upset Kenney went ballistic. He told Judge Sweeny that Rose denied confessing to the police or to anyone else. Kenney said she told him she had been taken to the prosecutor's office at 11:00 a.m. and was asked to sign a paper. She refused to do so, because she could not read the paper and because Kenney was not present. Rose also said they told her Kenney was in jail. She was told her attorney would be held there until she signed the paper and there would be no one to look after her children.

"Mrs. Veres told my witness she was hard up for money," Stutz said of the confession. "She told him she had tried with two of her lodgers to poison him twice in order to benefit by the $2,468 life insurance she had taken out for him. When I heard this and verified it, I obtained the warrant. I think such a confession is more convincing than one taken by police after many hours [of] questioning."

Shortly before noon, Judge Sweeny agreed to remand Rose and Bill to the Wayne County Jail without bail. He set their arraignment for September.

Stutz told reporters outside the courtroom that perhaps now additional witnesses would feel less intimidated by Rose's reputation as a "hex woman" and come forward to tell their stories.

"They have been too terrified to talk with us," Stutz said. "However, as soon as they heard she is held for examination, they have begun coming in voluntarily to inform us of the deaths of her other roomers."

Kenney rebuked any and all of the prosecutor's allegations. He told the newspapers that reports of his client's statements were exaggerated.

"While the woman has done all kinds of charity work for her penniless neighbors and while she is well thought of by many of them, she has a few enemies who are causing all this trouble. She has never confessed killing Mak because she did not kill him and police failed in their intensive grilling of more than 100 hours to make her confess that she did," Kenney said.

The *Detroit Times* was the only newspaper that published his comments. Its story claimed Rose became hysterical when she heard tales of her alleged declaration of guilt. Wringing her hands, she screamed in Hungarian to a female interpreter, who translated her words as, "I never talked to anyone but the police about this. It is all a lie." Rose declared Mike Ludi, roomer in her home at the time of Mak's fatal fall, had warned Mak not to climb the ladder to repair a window because of his age. Ludi offered to repair the window himself, Rose said.

A few days later, the *Detroit Times* interviewed Rose while she was in the county jail. Whitman wondered if Kenney had arranged for an exclusive story for Vera Brown or if the aggressive reporter had sweet-talked one of his officers.

For Brown, that interview was about as good as it got in building her byline at the *Times*. Brown described Rose as a "witch woman with the evil eye." Her gray hair was swept back into a loose bun, and her wrinkled face bore the markings of a woman who worked long hours. Her companion, a wan creature introduced as Mrs. Elizabeth Kovaks, sat by Rose's side as the translator.

Rose, hesitant at first, proved to be an excellent subject. Maybe it was because Brown was a woman and she didn't seem threatening. Maybe it was because Rose just felt like talking. Whatever the reason, Brown had more than enough material for an exclusive.

"All my life I have worked. That is all I know. I have tried to help others, and this is what I get," Rose said. "I do not understand everything that has happened. They say out there on Medina Street I was born with a veil and a full set of teeth," Rose laughed. "Maybe they mean [my cap]. I always wear a knit cap. I don't like my gray hairs. I have too many."

Detroit had grown larger and richer from its bustling automotive-manufacturing industry and factories; its downtown was bustling until the late 1920s, when the economy slowed. *Courtesy of the Library of Congress.*

Rose's crocheted cap had become as familiar as McCrea's starched hat. One told of work and exhaustion, Brown thought. The other spoke of new suits and ambition.

"Things have changed out on Medina Street. Two years ago the neighbors gave me a party on my birthday—the same people who now tell such things about me," Rose said. "There was $20 worth of chickens and wine and everything good to eat. I went to the bank and when I came home there was a gypsy orchestra there from the restaurant up on West End Avenue. It was a surprise, and the chicken were from the yard of Aaron Freed next door.

"Now Freed says he and his wife saw us beat up poor Steve Mak in the basement of our house," Rose said, her voice trailing off.

"I married a boy who lived three doors from my people. It is a small town. We had a little farm," Rose said. "My husband and I worked hard. But it was not easy to get ahead. [Then], he came to America. After a while he did not write. Finally, I came here to this country. I saved the money, little by little.

"When I get here, I found my husband living with another. He married another woman. I worked, saved money and got a divorce," Rose said quietly. "After a year, I married Gabor. He died four years ago. I have never buried him. He lies in the vault and every month I pay $5 for that. But I feel better, for I loved him. He was a good man.

"All the while he lived, together we had boarders and roomers. Sometimes I get up at 4 a.m. to cook breakfast for them when they work on the night shift. I cook good food, chicken sometimes, pork chops—everything good. My grocery bills sometimes are $150 for two weeks. I do the washing and make the garden at the back of the house. I have flowers, onions, leeks and turnips. That was my life.

"My husband and I, we saved some money and bought a home. Our boarders never even open their checks when they get them in an envelope

By the late 1920s, many of Detroit's tallest and stateliest buildings had sprung up, creating the city's dramatic skyline. *Courtesy of the Library of Congress.*

or they never open their pay," Rose said. "They give it to me and I bank it for them, and when they want money, I give it to them…for I can add and I know about banks.

"There were insurance policies on most of them," Rose added. "That is the way my people do. We want a good funeral. There must be flowers and lodge members and a priest. I give everyone a fine funeral.

"When my husband lived, I tried to help everybody," Rose said. "I loaned money to people who need it. I bought sugar and flour for them. When I was godmother to their children, I give them nice gifts. My husband earned good money. Then he died and all of that was over. When I could no longer give them things, they turned against me. I was no longer 'the angel of Medina Street.' Once they called me that. Now they say I murdered!"

On the morning of September 8, the courtroom was filled as officials brought Rose and Bill Veres in for their preliminary examination. It was showtime for Duncan McCrea, who now became the prosecutor's voice in the courtroom. And it was a big voice, indeed.

McCrea started as a city assessor. But he always had aspirations. McCrea tried out for every open position, cast his hat into every ring, stepped up for any new assignment. If there was a job to be done, McCrea was never above doing it. He began attending law school at night, and after years of study, he achieved his goal of becoming a lawyer.

His early years as an attorney were hardly glamorous; McCrea defended all manners of men and women. In one of his earliest cases as a new assistant prosecutor, McCrea was up against a piano company accused of publishing false advertisements. In court, the defense offered to deliver the promised pianos to McCrea's witness, only to garner his sharp reply, "We appreciate the generosity of your offer, but it comes rather late." McCrea once asked a fortuneteller on the witness stand why he didn't know he was taking a bribe from an undercover police officer, and everyone in the room loved him for it.

His cases started to get more newspaper coverage because reporters knew they would get a show inside and outside of the courtroom. McCrea adored the attention. He began to hold mini press conferences, making sure his name was front and center. McCrea's comments sometimes contradicted those of other city officials, but "Drunken McCrea" was good about taking that fellow out and buying him a few drinks to settle any rift. As long as he was making more friends than enemies, McCrea figured he was doing all right.

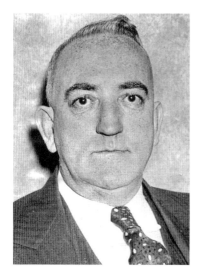

Duncan C. McCrea was an assistant prosecutor when Harry S. Toy took over the office; McCrea became Toy's right-hand man. *Author's collection.*

McCrea wasted no time putting his star witness before the court. John Walker, an African American man who rented the other half of Rose's duplex, testified Rose said her son and another man had beaten Mak before throwing him from the attic window. He also told the court Rose had offered him $500 "to keep my mouth shut."

Next, McCrea brought William D. Ryan of Receiving Hospital to the stand. McCrea began by asking the doctor if he knew the results of his autopsy on Mak's body.

A gruff voice interrupted. "Have you been working on that all this time?" Judge Edward J. Jeffries snorted.

Known for being one of the toughest magistrates on the bench, it was clear Judge Jeffries was in a sour mood. Called Detroit's "Fighting Judge," Jeffries was loud, theatrical and sarcastic. He looked like a kindly grandfather with his bushy hair and eyebrows. But he possessed a keen and compassionate legal mind.

"I just got the report of the chemist. He said there was no poison found," said Dr. Ryan, who testified to the cause of death as traumatic cerebral hemorrhage along with internal hemorrhages and puncture of the left lung.

McCrea finished, and the floor turned to Kenney. Speaking for the defense, Kenney stood up and addressed the judge.

"Your Honor, I desire to make the motion that the complaint and warrant, first against the respondent, William Veres, be dismissed and the defendant discharged for the reason that the testimony as brought forth in this examination has failed in any way to link or connect this man up with the offense."

Judge Jeffries looked up. "What is the charge against him?…The only testimony you got here is the testimony of this colored man. What did he say?"

McCrea stepped forward. "He said Rose called him over to her house and told him her and Bill and another man called Butcher and herself beat [the] hell out of this man in the basement and dragged him up through the trap door into the attic and threw him out of the window."

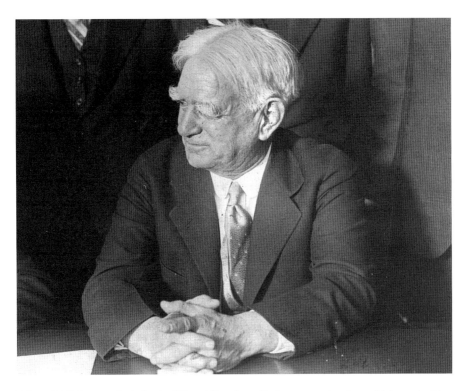

Edward Jeffries was the judge in Bill and Rose's preliminary examination, which resulted in the case being held over for trial. *Author's collection*.

Jeffries stared at McCrea. "Well, that testimony could not be used against him."

McCrea paused. "He was present."

Kenney shook his head. "No, he was not present, your Honor."

Jeffries turned to McCrea. "You are sure you are connected up?"

"I think I am," McCrea said.

"I am not talking 'You think.' I want the testimony," Judge Jeffries barked. "Well, don't stand there. Either do one thing or the other."

McCrea looked straight at Jeffries. "Well, I am recommending the defendants be held for trial."

Jeffries exploded. "I won't hold [Bill Veres] for trial unless it is connected up. There is nothing I see on the record that he was connected in it except her statement. You do not purport to have a statement out of him. Have you got a statement out of him?"

McCrea said "No."

The judge responded, "The trouble is this. The trouble is you people desire to convict people by suspicion."

McCrea jumped in. "I have no desire to convict people by suspicion."

"That seems to be the trend of the times and seems to be your sweeping accusation on the part of the prosecuting attorney, and those in administration, to sweep everybody off their feet by suspicion," Judge Jeffries said. "We are here yet in a court of justice, at least I hope so, in which we will follow out what protects people, that protects society against those who are guilty, and vindicates those who are innocent."

"Your conception over there is if juries and courts do not cooperate with the prosecuting attorney and do not do what the prosecuting attorney

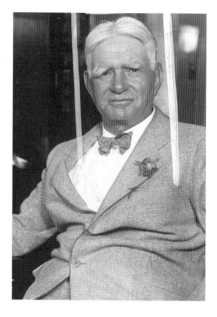

Judge Edward Jeffries was known as one of Detroit's toughest yet fairest magistrates, ruling his courtroom with his sharp tongue. *Author's collection.*

recommends, they are not cooperating with justice and therefore they are criticized for it," the judge continued. "Who are you? You are but an officer of this court—the same as every other officer of the court, a lawyer or a policeman or anybody else."

"Mr. Toy may go off in the wilderness and yell to his brethren, but he is nothing more than an officer of this court and he should do his duty impartially, fairly and justly," Judge Jeffries fumed.

McCrea, pale and quiet, said, "I can only speak for myself."

"Well, bring the testimony out so I can see the connection or else get your man back here and make the connection so I can clear it up," the judge replied. "Have him here at 9:30 tomorrow morning."

That next morning, Walker testified again, and. Jeffries agreed to hold Rose and Bill Veres over for trial. But he did so with a warning to both attorneys.

"It is a question of fact for a jury as to whether they believe this man is telling the truth or not. You may get a jury that will believe him," Jeffries said. "I will hold them for trial and remand them to the sheriff of Wayne County without bail."

4
"HOW COULD THEY DO IT?"

Detroit Recorder's Court drew a crowd on October 1, 1931, as people gathered to watch the city's now-infamous "Witch Woman" go on trial for her life. Delray neighbors showed up dressed in their finest. Courtroom faithful and the attorneys wore dark suits befitting the weight of a first-degree murder case. Even the looky-loos who snagged the remaining seats inside Presiding Judge Thomas M. Cotter's courtroom seemed to understand the gravity of the situation.

They had reason to be curious. Newspaper reports labeled Rose Veres with words intended to spark interest, even fear. In the weeks leading up to the trial, Rose was described as "shriveled." One report said her face carried a look of "sullen defiance." The *Detroit Times* said, "the woman looks older than her 48 years. Her face is sallow and heavily wrinkled, her hands large and work-worn." To writers such as Vera Brown, Rose's only standout feature were her eyes. "The woman's eyes are peculiarly large and of a peculiar pale blue," Brown wrote. "At times in her dull face, they appear to be the only part of her that is alive."

As a result, Rose Veres was the center of attention as the courtroom settled in that October morning. Rose seemed weary after a month of incarceration. But her expression softened when she saw her firstborn son enter the courtroom. The sudden warmth of her smile surprised the reporters covering the trial.

Bill, who also faced first-degree murder charges, came in wearing handcuffs, a loose suit coat and a fresh haircut. His expression also

The Detroit Police Department tried to participate in city events and in neighborhoods to show its solidarity with residents. *Author's collection.*

brightened when he saw his mother at the defense table. They briefly embraced, greeting each other tenderly and exchanging a kiss.

McCrea stood alone at his table. In the hallway before the proceedings, the ruddy-faced lawyer told reporters he expected jury selection to be swift; he wanted to finish the task on the first day. McCrea added that should Rose and Bill be acquitted, he would continue to investigate the link between the Veres family and the other deaths in their Medina Street boardinghouse. Reporters eagerly took their seats inside Cotter's courtroom, drawn in by McCrea's additional promise to call "a new and unnamed witness" to the stand when the state started its case.

The assistant prosecutor held true to his word. After two hours of intense questioning, eight men and four women made up Rose and Bill's jury. McCrea used only two of his challenges, while Kenney peppered the court with nine. Two other potential jurors were excused, saying they were prejudiced in the case. As jurors were sworn in, Judge Cotter told them to avoid reading anything about the case; any issue with what the

jurors saw or heard may force them to be sequestered after the start of testimony, he warned.

In his opening statement, McCrea approached the jury with intensity. The state would show Rose and Bill conspired to kill Steve Mak, their innocent roomer. First, they tried to poison him. When that failed, they beat him in their home's basement with their fists and a deadly weapon, making him bruised and bloody. Together, they dragged Mak's body upstairs and pushed him from an attic window and to his eventual death. Mak suffered for two days from those injuries. He died, alone, far from friends, countrymen or comforts of any kind. The trade for a man's life? A life insurance policy worth $4,000.

Kenney answered McCrea's opening volley. The death, the attorney argued, was an accident. Mak had gone up the ladder to repair a broken window, slipped and fell to the ground. Moreover, Rose wasn't home when the fall occurred. She was outside when a neighbor ran to tell her the news of Mak's injuries. There was no way Rose could have beaten the heavyset man and carried him upstairs to push him to his death. Moreover, her son Bill was at a movie theater at the time of Mak's fall, making him an innocent bystander in this case.

Rose and Bill sat quietly during these statements, their expressions unreadable. Bill, who stood five feet, four inches, seemed lost as he watched the courtroom's actions swirl around him, nervously snapping his gum during the state's testimony.

McCrea opened the case with his first witness, Dr. William G. Ryan, the Wayne County medical examiner. Ryan established the cause of death as a cerebral hemorrhage. A number of bruises and cuts were found on the body, he said. Dr. Isadore Shapiro also testified to Mak's medical condition. Judge Cotter stepped in at one point to ask, "Was there any evidence of a blow by an instrument or shock or otherwise?"

Dr. Shapiro responded, "No, there was not."

Next up was Rose Szabo, one of Rose's neighbors. Reporters described the petite woman as terrified when she took the stand to give her testimony. At the first question, Szabo jumped from the witness chair and hurried to get out of the witness box. McCrea was merely asking her name.

McCrea saved his star witness for last. John Walker was a forty-year-old African American man from North Carolina who came to Detroit around 1920 to work in the Studebaker factory. Walker, like so many others, was laid off as the Great Depression hit. Walker started taking odd jobs, including cleaning alleys for the City of Detroit. He was on the dole when he went to

Henry Ford's car company, which produced these police vehicles, was one of the largest employers in Metro Detroit. His promise of "Five Dollars a Day" drew thousands of men to Detroit to work. *Author's collection.*

live in the other half of Rose's house. He told Rose his welfare check would pay his rent of fifteen dollars a month.

McCrea led Walker through that fateful August 23. Walker said he, his wife and their three children had been living in the other half of Rose's duplex for about three weeks when the incident happened. Walker said he didn't know Mak well, but the two recognized each other by sight. Walker testified he saw Rose on and off all morning. Between 10:00 and 11:00 a.m., Walker said he talked with a neighbor named Walt Moore and they watched as Rose placed a ladder against the east side of the house. Moore told Rose the ladder was upside down and it would not reach the attic window. Walker said Rose paid her neighbor no attention and walked away.

That afternoon, Rose knocked on his door; he didn't answer. Walker, hoping to catch a nap before his family came home from church, purposefully ignored his landlady. Undeterred, Rose came around to his bedroom window, pulled the shade back and said, "Some children are

dying out here," Walker testified. Noticing he was trying to rest, Rose added, "Never mind, John, sleep on."

Upset by her statement, John got up and walked outside. He wanted to check on the ladder, wondering if some kids had gotten near it and were causing trouble. After he saw the ladder was secure, Walker testified he stopped to chat with neighbors. Rose dropped by again, giving some old stockings to Walker's wife, who was now home.

"I told my wife, I said, 'She is a pain, ain't she?' and my wife said, 'Yes,'" Walker told the court. "She came back to her door and said, 'Come on, John, come on.' So I went on around there to see what she wanted….She told me to attach the hose and come on in and wash off the porch and chase [the neighborhood children] outside."

Judge Cotter interrupted Walker's testimony. The judge, who had asked McCrea to clarify that Rose Veres was the defendant several times at this point, seemed perturbed.

"Now, McCrea, this may all well be clear to you but I don't know how a Court is going to rule on a matter of this kind because I don't know what you are talking about," Judge Cotter said. "I know there is a charge of murder. I don't know the theory. I don't know what you are proposing to do or what."

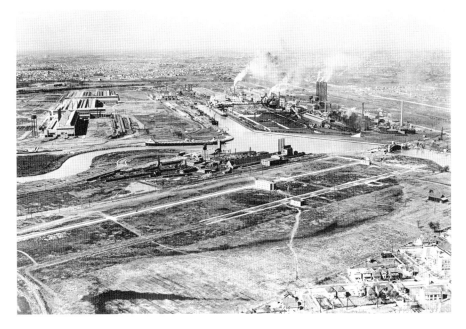

The Detroit River used to hold houseboats and other small craft before factories settled along its edges in Delray and River Rouge. *Courtesy of the Library of Congress.*

McCrea paused. "Well, I will show you, your Honor."

"What is your theory about it?" Judge Cotter asked. "I mean, how was he murdered?"

"Well," McCrea said. "He was pushed from the attic window, among other things, and fell down, striking the house across a little narrow alleyway, and landing down there and he was taken to the hospital and died."

Judge Cotter asked, "Well, the fall was the cause of death, is that it?"

"Either that or the beating before, your Honor. There is evidence of both. However, the man came out of the window head first and landed on the ground there."

Judge Cotter replied: "All right. I am not in the habit of reading these so atrocious murders and beastly conduct of people. So don't take anything for granted that I know anything about it."

McCrea continued his questions to Walker. "Then what did you do?"

"Well," Walker said, "I went outside and after I got outside right by the gate, I cut the water off, and a cigar box fell from the attic window, and I looked up, and when I looked up, I saw a man come out of the window."

McCrea asked, "How did he come out?"

Factories such as the Detroit Edison Electric plant arose around Delray because of its access to the water and the area's substantial natural resources. *Courtesy of the Library of Congress.*

"His face down," Walker said. "He hit Mr. Moore's house, and when he hit it, it knocked him back and he just fell over on his back and both arms stretched out."

Judge Cotter interrupted. "Did you look at him? Was there anybody else there with you?"

Walker testified that a gang of people had arrived by then. McCrea tried to redirect. "Well, did you see Rose Veres after that?"

Walker said he did, about five minutes after Mak's fall. "She came through the alley, from the alley into my gate," Walker testified.

Around 6:00 p.m., Walker said he and Rose Veres were taken to police headquarters together in a squad car. During the ride, Walker testified, Rose told him to keep his mouth shut about Mak's fall. Walker admitted he lied to police when they asked if he saw Mak fall.

Walker testified when Rose and he arrived home, Rose came into his house at about 11:00 p.m. to ask to borrow $1.50. "She said she wanted to pay up the old man's insurance, and she ask me did I think that old man would die, and I told her if that man didn't die the condition he was in, you couldn't kill him, and she got up and said, 'Come on, John, come on, I want to talk with you.'"

At that point, Walker testified, they left Walker's house and went into Rose's home. There, Rose confronted him.

"She told me to keep my mouth shut, if the old man died she would get the $4,000 worth of insurance and she would give me $500," Walker testified. "When she told me that, I told her: That is your business, it ain't none of mine. I ain't got anything to do with it."

That is when Bill Veres walked in, Walker said.

"Bill asked me did I think the old man would die, and I told him, 'Yes,' and he asked me about the blows he had on his head," Walker testified. "He asked me what about the licks he had on his head and asked me to point out the blows....He asked did I think he would die."

In his cross-examination, Kenney worked Walker over about the timeline. Kenney hammered away at when exactly Rose threatened Walker to "keep his mouth shut" and offered him $500 of the insurance money. Under the attorney's questions, Walker testified Rose and he had the conversation between 4:00 and 5:00 p.m., after Mak had been taken to the hospital but before the Detroit Police Department arrived on the scene. Kenney also got into what exactly Walker told detectives at police headquarters.

"What kind of a statement did you make to this man that you talked to?" Kenney asked.

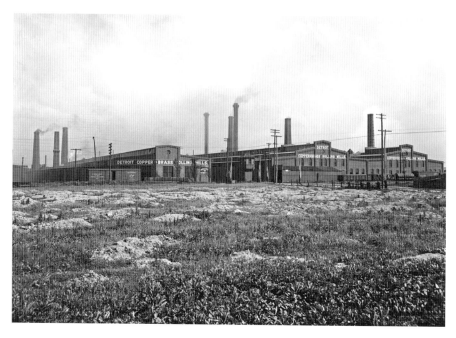

Delray became an industrial area early in the 1900s as manufacturing facilities like Detroit Copper and Brass settled there. *Courtesy of the Library of Congress.*

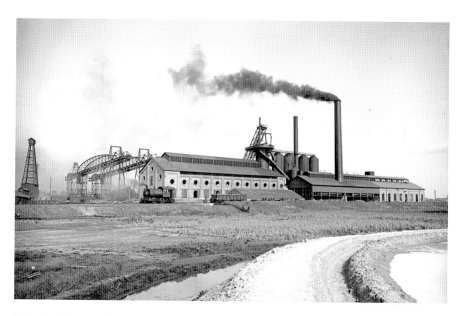

Delray's skies were frequently filled with smoke and contaminants from factories such as Detroit Iron and Steel, and residents complained about the impact on their families. *Courtesy of the Library of Congress.*

"I made the statement that she told me to make," Walker testified. "I told him [Mak] fell off the ladder."

Kenney probed further. "And that you saw him fall off the ladder?"

"I did," Walker testified.

Kenney looked at Walker. "Is that right?"

"Yes."

"And you tell us now that is not the truth?" Kenney asked.

"It ain't," Walker testified.

When the court reconvened on October 2, a neighborhood girl took the stand. With her short bob and knee socks, eleven-year-old Rose Chevala charmed reporters. She told the court she lived across the street from Rose's house. She said she saw Mak climb the ladder at the side of the house, enter an attic window and come tumbling down. When he was picked up by the ambulance, she said Mak was not wearing shoes. "I thought he tripped," Chevala said.

A Hungarian man named George Halasz testified next. Halasz, a former boarder in Rose's home, had left under bad terms. Through an interpreter, Halasz said he was standing outside of the Vereses' home when he heard angry voices coming from the attic. He identified the voices as Rose, Steve Mak and "one or more others." He then said he saw Rose push Mak out of the window.

In his cross-examination, Kenney zoned in on the details of Halasz's memory, asking him what Mak was wearing that August day. Halasz said Mak was dressed in a blue shirt, a sweater and dark shoes.

Testimony continued with Mickey "Mike" Boldizar, who told the court the day after Mak's fall, Rose Veres told him she had "bumped off Mak when poison didn't work." He said he also talked with Bill Veres and heard him threaten that "after things blew over" he would get even with the person who reported the case to police.

McCrea then brought Bessie Hill, who lived next door to the Veres home, to the stand. She testified she was inside her house when she saw a box of nails, a hammer and a saw fall or were thrown down from the window in the Vereses' house. She said shortly after Mak fell, Mrs. Veres came into her home. "Mrs. Veres came into the kitchen and washed her hands. They were very dirty," Hill said.

Final witnesses included Mike Ludi, another former boarder. Ludi said Rose had asked him to fix the window, but he didn't do it so he could go to

Within a few decades, factories such as the Malleable Iron Works absorbed much of Delray's riverfront access. *Courtesy of the Library of Congress.*

the basement and sleep. Then came Aaron Freed, who testified he heard Rose threaten to cut Mak's throat; under cross-examination, he admitted he was not on friendly terms with Rose. The day ended with two homicide detectives, Rudolph Schwab and Earl Switzer, who were among the investigators on the case in the hours after Mak's fall.

Kenney asked Switzer what he learned from Rose Veres when he was on the scene on August 23 to investigate Mak's fall.

"I talked to Mike Ludi and John Walker, and Rose Veres was there but we didn't talk to her; she couldn't talk English," Switzer testified.

Kenney repeated, "She couldn't speak English?"

"No," the detective replied.

AFTER TWO DAYS of intense testimony, jurors were sent home. Saturday was a day of rest, but they were back to work on Sunday, October 4, to see the scene of the alleged crime. Judge Cotter, who had agreed to Kenney's request to make the trip, came along, as well. Bill was in handcuffs and cuffed to a policeman; Rose walked next to Kenney. Jurors were shown through the basement where witnesses said Rose, Bill and a boarder beat Mak. Jurors also climbed the ladder from which the defense says Mak fell from the attic.

On Monday, Kenney came back to court with news that neither Rose nor Bill would take the stand during the trial. He opened his defense with Whitman, who testified that Rose had never made any admissions concerning Mak's death. Whitman also said Rose throughout his questioning maintained her original story that she was in an alley behind her home when Mak fell.

Detective Charles Schneider was next. Schneider explained the broken plaster, which the jurors saw in their visit to the Veres house on Saturday, was intact when he began the investigation. Kenney introduced this evidence to combat the possibility that the jury might have considered the broken plaster as evidence of a struggle. Schneider also testified he had made a complete search of the whole attic and there were no signs of blood or struggle.

Kenney dived in deeper. "Did you see any blood stains around there?"

"No, sir, I did not," Schneider replied.

"When you made your search, did you find any blood stains anywhere in that house, basement, the first floor or the attic?"

Schneider again said, "No, I did not."

In all, Kenney brought eleven of Rose's friends and neighbors to testify on Monday, hoping to counter the testimony of the state's key witnesses. There was Mrs. Verona Kovalch, who lived across the street from Rose. She testified she was first at the scene when Mak struck the ground and she did not see Walker nearby. Gabriel and John, Rose's other sons, testified their brother Bill was not home when Mak fell; he was at the movies.

The defense rested. Judge Cotter addressed the jury, giving them their charges in this case. In particular, he called attention to the hole in the ceiling at Rose's house.

"You saw the plaster. There isn't any claim on the part of the State that the plaster you saw broken in the kitchen, and in that other room was broken at the time of the alleged killing. The police officer stated that the plaster was broken since, possibly by the men walking up around in through there or in some other way. I don't know. But, anyway, that was not the condition of the premises at the time of the alleged killing."

Judge Cotter also referred back to McCrea's opening statement. "It is the theory and the claim of the State here that Mak, the deceased, was killed by these defendants and that they pre-meditated the killing, that they planned it, that there was deliberation."

Jurors retired to the jury room at 5:33 p.m. More than two hundred spectators remained in Cotter's courtroom to await the verdict. At 6:30 p.m., the jury went to dinner. Around then, counsel for both sides agreed the clerk

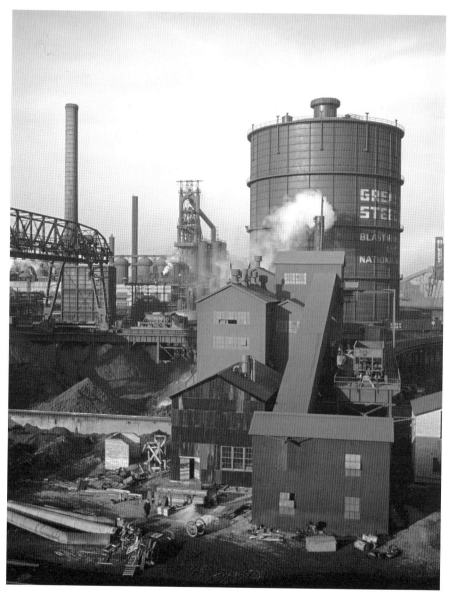

Zug Island, the small landmass between Delray and River Rouge, was home to some of the largest steel factories in Detroit. *Courtesy of the Library of Congress.*

could take the verdict in the absence of the court so Judge Cotter could come and go as needed.

The first vote came back nine to three to convict. The second vote was eleven to one. Around 8:00 p.m., the jury asked to examine the window sash used as state's evidence. Finally, on the third vote, the decision was unanimous.

Judge Cotter was not present when the jury announced at 9:22 p.m. that it was ready. The jurors were brought into the courtroom.

The jury foreman read the verdict: "We find the defendants guilty as charged of murder in the first degree."

Both mother and son now faced mandatory life sentences. Rose's Medina Street neighbors who had stayed throughout the trial began to weep.

Rose showed no sign of emotion, maintaining what newspapers described as the same stoic expression that characterized her through the trial. Bill, who had tears in his eyes upon hearing the verdict, wilted. He bowed his head while the jury was dismissed.

Judge Cotter, who was now back in court, told the attorneys he would sentence the mother and son in a week.

Outside the courtroom, Kenney told the newspapers he would seek a new trial for Rose and Bill Veres. He said he would base his motion on "error in the trial and on the judge's charge to the jury." He planned to seek a new trial before sentencing.

Bill, visibly crushed by the jury's decision, said only one sentence to the gathered reporters: "How could they do it?"

OPEN FIRE

Frank M. Kenney Jr. liked to win. He got such a charge out of it that he was well known among Detroit's legal community for throwing a beer party in 1930 after jurors acquitted his clients on assault charges. Judge Henry S. Sweeny, the magistrate in the case, ordered an investigation into the alleged kegger. Judge Sweeny also said he would take the matter before the entire bench of the recorder's court and the Detroit Bar Association. When questioned, Kenney told investigators: "It was a celebration. That case was a hard one. The defendants were all innocent. And after that jury was out 26 hours, everyone was tired....I don't see anything wrong in it."

Now nearing thirty, Kenney had worked hard to build a reputation with the court. He knew he had failed Rose and Bill. In the days following their guilty verdict, Kenney filed motion after motion, hoping to get more time to work on a new trial. However, it only served to postpone the inevitable. The judge denied Kenney's request for a delay in sentencing.

Rose and Bill were brought back to court on October 15, 1931, to hear their fate. Judge Cotter went over the court psychological evaluations. Rose's report declared her "not insane but a very dangerous woman." The probation department described her as a menace. The same report found Bill was under the influence of his mother, unsocial and not fit to be in society. It also placed his intelligence level on the same level of an eight-year-old child.

Both Bill and Rose had records with the probation department. Bill had been on probation in the juvenile court since April 1930, when he had been caught breaking and entering. Rose, too, was on probation stemming from

an October 1927 incident in which the court chastised her for not sending her youngest son, John, to school. That report also noted Rose had been "on the dole" for years.

Kenney appealed to Judge Cotter once more. He asked the judge to consider giving him more time to seek a new trial for his clients.

"Jurors came to me and said that after thinking things over that theirs was not the true and proper verdict," Kenney said. "They phoned me of their own volition. In such a serious case as this, all should be done to allow the defendants every possible advantage that the law allows."

Judge Cotter didn't mince words.

"I have not received any complaints from any of the jurors," Judge Cotter told the defense attorney. "All this is entirely new to me. Just your statement alone is not sufficient to have the court delay sentence. The defendants, in my opinion, had a fair trial. The jury was attentive, careful and arrived at an honest verdict."

Throughout the proceedings, Bill seemed shaken, hardly looking at his mother or attorney. When Judge Cotter announced his sentence of life at Jackson State Prison, Bill broke down.

"I am not guilty of this crime," he cried out. "I was not home when it happened. I did not have a fair trial."

Rose sat in the prisoner's box as Cotter completed Bill's sentencing, never taking her eyes off of her attorney. Bill, still dazed, helped translate Rose's comments to Kenney as they prepared for the judge's ruling. She stood mute before the judge as her term of life at the Detroit House of Correction was read. At one point, she slumped in a half-faint; Bill caught her before she fell.

When Rose finally addressed the court, it was in Hungarian. She spoke to Bill, who translated it for the court. Bill told the judge his mother asked what he and Judge Cotter were saying to one another. Rose spoke again in her native tongue, and her son repeated her words as, "I am innocent."

Their sentencing and the aftermath became fodder for Vera Brown's *Detroit Times* column, in which she told a grim tale of Rose's night in jail. Rose sobbed in her cell and beat her head on the wall, Brown wrote, lamenting not her own fate but that of Bill. "For me, I do not care. But for my boy. My poor boy," Rose said. During her sorrow, the other female prisoners talked in low voices to show their sympathy, according to Maybelle Reynolds, a deputy on Rose's floor. Brown said Rose clutched her rosary, praying while "tears streamed down her wrinkled face." Protesting her and Bill's innocence, Rose wailed: "Save my Bill. Kill me if you want. You save my boy. His is so young."

ON NOVEMBER 4, Kenney sent Prosecutor Harry S. Toy a copy of his motion for a new trial for Rose and Bill. In his request, Kenney said the defendants were innocent and the evidence did not prove their guilt. Kenney narrowed in on the court errors, including its refusal to allow Dr. William Ryan to answer a hypothetical question as to how Steve Mak received his injuries, its failure to force John Walker to make direct answers to questions on cross-examination and its failure to grant Kenney's request that the jury be locked up during the trial due to the "wide newspaper publicity given this case."

In an attached affidavit, Kenney wrote that Judge Cotter left the courtroom for as long as half an hour at a time. On another occasion, both McCrea and Kenney needed to consult the judge on an issue, only to find he was not in his office. For these and other reasons, Kenney said "these defendants have not had a fair trial and that this Honorable Court should in the interests of justice grant these defendants a new trial at which time it is the belief of this Deponent that they will be acquitted."

McCrea and Kenney were scheduled to be back in court on November 13 for a hearing before Judge Cotter. Both parties agreed to adjourn the hearing until December 3. Another adjournment came on that day. The motion before Judge Cotter was pushed back to December 17.

On December 17, McCrea asked the court for the hearing to be adjourned again because he was engaged in a case before the circuit court. Kenney agreed to the stipulation, and the motion for a new trial was pushed back to January 21, 1932.

On January 21, Kenney agreed to another adjournment on his motion for a new trial for Rose and Bill until February 16.

From there, the record is silent.

Personal and professional problems began to plague Kenney. On September 25, 1932, Kenney told reporters he would take on a case for his brother William. Twenty-two-year-old William Kenney claimed two Detroit police officers had beaten him; supposedly, they struck him in the base of the skull with a pair of handcuffs. The altercation happened when an officer asked William to move his car, and William did not comply as quickly as the officer liked. Police told the newspapers William refused to show his driver's license; when he did, the license was expired. The officer in question denied striking the young man, noting William "fought like a tiger" when they tried to put him in the patrol wagon. Frank Kenney said he would take his brother's complaint to the city council and follow it with a $50,000 damage suit against the officer and the city.

Four days later, Frank Kenney himself was arrested on a charge of disturbing the peace over an altercation with a cab driver. The two were fighting when a police officer came upon the scene. Kenney was taken into custody. At the McGraw Avenue Station, Kenney refused to let officers take his fingerprints. Kenney was held until assistant prosecutor George M. Stutz ordered him released. In October, Kenney went before Judge John A. Boyne to defend himself against the charge. Kenney testified he was not the man the cab driver said entered his car, asked to be driven to Detroit and got into an argument over the $3.50 fare. The case adjourned upon Kenney's request that he needed time to find a witness he planned to use as his alibi.

In November, Kenney was back in the newspapers again. This time, the Detroit Bar Association disbarred him from practice for the period of one year. The disgrace was so substantial that an attorney with a similar name sought to separate himself from the incident. In a letter to the *Detroit Free Press*, two circuit court judges wrote on behalf of Frank E. Kenney and his associates at Lawhead & Kenney. "The similarity of their respective names is causing Frank E. Kenney, who bears an honorable reputation, a great deal of embarrassment. Therefore, in justice to him, we respectfully request that an article be run in a prominent place in your paper to distinguish the name of Frank E. Kenney from that of the said Frank M. Kenney Jr."

In November 1934, the *Detroit Free Press* reported Kenney was being held at the Jackson County Jail on a drunk-driving charge following a minor accident near Parma on US-12 on November 19.

In January 1936, Kenney was back in court when a state assistant attorney general filed a petition for his disbarment on the grounds of "unethical practices, fraud and deceit." Five people had filed grievances against Kenney. Four said they had paid him money to work on their cases, but nothing had been done on their cases. A fifth claimed Kenney collected a $265 judgment for him, but he only received $100 of it. In light of the previous complaint, the *Free Press* ran a small article indicating this Kenney was not related to the Frank E. Kenney of Lawhead & Kenney, perhaps hoping to avoid any further letters to the editor.

On April 3, 1937, a trio of visiting judges disbarred Kenney again, noting he accepted money in cases for legal services he failed to render.

Sometime after his disbarment, Kenney and his wife moved to New York. There are no records in Michigan or New York indicating he ever practiced law again.

THROUGH COUNTLESS HOURS and hard work, Harry S. Toy had built a reputation as Wayne County's law-abiding prosecutor. From 1931 forward, he had sent numerous criminals to prison, including the men who murdered radio host Gerald Buckley, Detroit mobsters including Pete Licavoli and James Moceri, members of the infamous Purple Gang and dozens of bootleggers. Detroit felt safer under his watchful eye.

Busy as he might be, Toy found himself going to court for another reason: Fixing the latest problem Duncan C. McCrea created. Once, McCrea had been Toy's go-to assistant prosecutor. Now, McCrea was becoming a liability.

First, Toy had to soothe the ruffled feathers of one judge after McCrea accused the magistrate of ethical violations. Then, McCrea went to the newspapers claiming $30,000 had "changed hands" to prevent the extradition of a murder suspect from Ohio to Detroit; the governor of Ohio was so incensed he demanded an apology. Another time, Toy had to take McCrea off of a case concerning a defunct bank because the assistant prosecutor refused to cooperate with the attorney general's office.

The tension heightened in July 1932 when McCrea announced his candidacy for recorder's court judge. McCrea tendered his resignation to Toy that October. An incensed Toy publicly supported McCrea's opponent during the campaign. It was a strange election, especially after McCrea claimed someone had tried to assassinate him. He told newspapers a bunch of hoodlums had shot at his home and he escaped by flattening himself on the front lawn.

Although McCrea's bid for the judicial post was unsuccessful, the damage was done. "After his defeat, McCrea asked me to reappoint him, and I refused to do so, giving him my reason at the time," Toy told reporters.

The two were back in the news in December 1932 when Toy reported McCrea to the Michigan attorney general. Toy said McCrea and his friends formed what he described as a "blind pig legal defense organization." For a $5 membership and a $5 monthly payment, McCrea and his cronies told people running illegal blind pigs they were "assured of legal aid and payments of any fines up to $100." Two police officers also were named in McCrea's plot; one of them had been assigned to guard McCrea after the alleged attempt on his life during his run for judge.

Problems continued in May 1933 when McCrea sued Toy for $100,000 in a defamation of character suit. McCrea claimed Toy had tried to block the prosecution of officials in a defunct bank—the same case in which Toy had removed McCrea the year before. In his suit, McCrea charged Toy was jealous of his record as an assistant prosecuting attorney. Toy dismissed the

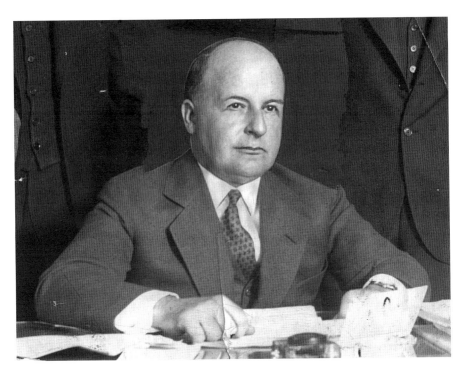

Harry S. Toy became the Wayne County prosecutor in 1930 after a campaign focusing on Detroit's rising crime levels. *Author's collection.*

lawsuit publically in newspaper reports. "The results would seem to show Mr. McCrea's charges to be false," Toy told the *Free Press.* "Nine convictions in the case mentioned would indicate that the prosecution had not been blocked by anyone."

Toy bristled at the accusations, saying McCrea only wanted to damage Toy's reputation, it was a political move and McCrea's efforts "brands him either a hypocrite, a liar or both." An irritated Toy even pulled out McCrea's resignation letter, noting his former assistant had written, "It is with deep regret that I take this step to break an association that has extended over eight years and brought much to my life."

By the fall of 1934, Toy had his eyes on the position of state attorney general, and his chief assistant, W. Gomer Krise, had entered the primary as a Republican to take over Toy's old job as prosecutor.

The Democratic candidate? Duncan C. McCrea.

Both Toy and McCrea won their respective races. McCrea handily won by sixteen thousand votes. Toy and McCrea's battles resumed immediately.

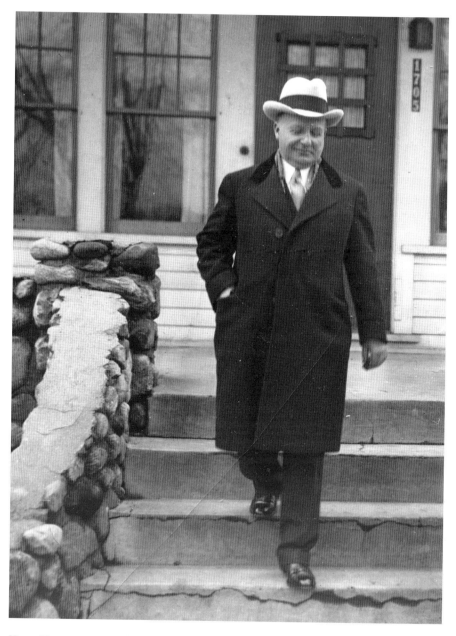

Harry Toy was connected to some of Detroit's biggest movers and shakers, including Father Charles Coughlin, whose home he is seen leaving. *Author's collection.*

Toy scoffed publically at McCrea's first moves as prosecutor-elect, hinting that McCrea's efforts in a bribery case were politically motivated. McCrea accused public officials, including Toy, of stuffing the ballot box, creating a court case that dragged on for years.

McCrea took office on January 1, 1935, as the new Wayne County prosecutor. The newspapers opened fire four days later.

On January 5, two of McCrea's newly appointed investigators were exposed for having police records; one was on probation for a liquor law violation. The men resigned, and McCrea promised to investigate his investigators. McCrea had to fire another assistant when court documents revealed he was a bigamist. The *Detroit Free Press* made the prosecutor's office its top news story on January 20 with the headline "Public Is Bewildered by New Prosecutor and Assistants, Whose First 19 Days in Office Bring Sensation after Sensation." The "whirlwind of scandal" encircled the office's new regime, the newspaper stated. The story recounted issues of McCrea showing up "slightly inebriated" during election-recount hearings.

Toy and McCrea's names would be linked time and again until Toy left the attorney general's office in October 1935 to become a Michigan Supreme Court justice. McCrea made the headlines again in a report about his alleged membership in an underground organization called the Black Legion. The Black Legion was akin to the Klan, focusing its terror on blacks, Catholics and Jews. At its height, it had an estimated 100,000 members in Michigan and nearby states. McCrea said he accidentally signed a membership card for the infamous group—an issue particularly egregious given McCrea was the prosecutor in a Black Legion murder trial.

Despite the negative publicity, McCrea once again threw his hat into the ring to serve as Wayne County prosecutor. This time, Chester P. O'Hara stepped up to run as the Republican opposition. O'Hara was a worthy opponent. Born in Muskegon, O'Hara had graduated from the University of Michigan and at the age of twenty received special dispensation from the Michigan Supreme Court to practice the law before turning the age of majority, or twenty-one. At twenty-three, O'Hara was elected Berrien County prosecutor, serving four years. Afterward, he became St. Joseph's city attorney and secretary-treasurer of a private company. In 1930, he returned to law to serve as an assistant prosecutor under Toy. He followed Toy to the attorney general's office in 1935. O'Hara was a household name, particularly after successfully prosecuting twenty people on charges of voter fraud in the 1934 election, including the chairman of the Democratic State Committee.

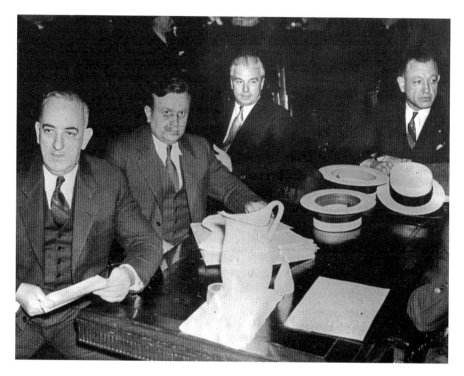

In the mid-1930s, Duncan C. McCrea (*far left*) and John A. Ricca (*second from left*) were the top lawyers for Wayne County in the Black Legion murder trial. *Author's collection.*

O'Hara had every advantage in the prosecutor's race. An October 1936 *Detroit Free Press* editorial railed against McCrea and begged the voting public to vote for O'Hara. "If you want this County overrun with crooks and criminals, vote for McCrea. If you want the protection of a capable and fearless fighter against crime and corruption, vote for Chester P. O'Hara."

Even with Toy's endorsement, O'Hara lost. According to the newspapers, McCrea snowed his opponent during the election, which also brought Thomas C. Wilcox to office as sheriff.

In 1938, Richard W. Reading became Detroit's mayor. Reading, once described as "5 feet, 3 inches of smiling geniality" by the *Detroit News*, had been elected in 1925 as Detroit city clerk. He held a variety of jobs during his youth, from semipro wrestler to galley boy at the *News*. His frequent attendance at local events made him a crowd favorite. Reading once bragged he knew more people by their first names than anyone else in Wayne County. The *Detroit Free Press* endorsed Reading for mayor,

Richard W. Reading (*far right*) became Detroit's mayor in 1938 based on his experience as city clerk and popularity among voters. *Courtesy of The Library of Congress.*

saying, "Reading's life has been a life of honesty, efficiency and steady progress....By electing Mr. Reading to be mayor, the people of Detroit will be recognizing merit and will be doing themselves a service."

Reading promised a level-headed government. He told reporters, "I believe in a wide-awake, progressive police, but that does not mean a wild orgy of spending—rather, a progressive policy whereby the City will have the necessities without the frills." Weeks later, Reading drew criticism for having the city buy a new limo for his use as mayor. The previous mayor had used his own vehicle while in office. Reading defended the purchase, saying, "I intend to take this mayoring seriously."

Detroit seemed like it was on the upswing. The Great Depression was fading into memory. The economy was slowly improving. President Franklin D. Roosevelt would soon ask the city's business leaders to retool their factories for the nation's entry into World War II, setting up Detroit as the Arsenal of Democracy.

Appearances, however, can be deceiving.

The suicide of a woman named Janet McDonald would unravel the city's wicked web, revealing corruption at its highest levels. The lives of Reading, McCrea, Wilcox and dozens of others would never be the same. And, soon enough, their undoing would serve as a new beginning for Bill and Rose Veres.

6
NO ONE WAS SAFE

On August 5, 1939, Janet McDonald dressed her eleven-year-old daughter Pearl in the girl's favorite pink taffeta party dress and walked from her Detroit home to the family car. McDonald ran a tube from the exhaust through the car's window, started it up, held her daughter in her arms and waited for carbon monoxide to fill the small space. The only witness to their deaths was a pile of handwritten letters resting neatly on a nearby seat.

In the lonely hours before she died, McDonald wrote long diatribes to her ex-boyfriend, the local newspapers and the head of the Federal Bureau of Investigation in Detroit. In those notes, McDonald accused her former love of being the go-between for the mob to deliver protection money to Detroit police officers.

McDonald had been a clerk in a numbers joint when she met William McBride, a small-time operator in the Detroit underworld. The divorcée and the gambler had an affair, and McDonald was smitten. McBride, however, was not. He broke up with McDonald, failing to realize the one thing that made her memorable—besides her handsome looks and Irish brogue—was an incredible sense of revenge.

"Dear Sirs," McDonald wrote:

> *It seems there is a good deal of vice going on in Detroit, and as long as the police are a part of it, it seems perhaps the government should know something about it in order to do a bit of cleanup work. I am*

privileged to know that the so-called G-Men are watching a certain Wm. McBride. This McBride was a partner in the Great Lakes Numbers house on Oakland Avenue, which closed down July 1. While the Great Lakes was in operation, McBride took care of the bribe end. He paid [a Detroit police lieutenant] *a neat sum monthly, also a large number of sergeants and officers got their portion each month. As long as a number house or handbook paid off, it was allowed to run.*

In her suicide note, McDonald wrote, "Life is so lonely and untrue that death has a tremendous appeal." In a letter addressed to McBride, she said she killed herself in part because "I told you the only way you could have another mama would be over my dead body." She also warned him, "in spirit I'll return and curse any woman that you make a friend of until the day you die."

In a letter addressed to the *Detroit News*, McDonald targeted McBride in particular. "He glories in telling lies, so don't believe everything he tells you, as I did," the distraught lover wrote.

As McDonald hoped, her letters caused a sensation. At first, some local officials tried to dismiss her claims, describing McDonald's writing as "the work of a frustrated, demented woman."

When the newspapers started asking questions, Richard W. Reading— who had filed his petition for reelection as mayor just two days after McDonald's death—told police superintendent Fred W. Frahm to investigate. Frahm appointed his chief inspector to look into the situation. Within seventy-two hours, the case was closed, exonerating the Detroit police lieutenant who McDonald had exposed. Mayor Reading suggested a grand scheme was in place targeting trustworthy city employees. "The critics of the Police Department," he claimed to newspaper reporters, "are chiefly from the CIO and the Communist Party."

If anyone thought the city's prosecuting attorney might step in to question the situation, they were wrong. McCrea, who had called himself the "Fighting Prosecutor," was anything but. He had been away on vacation when the McDonald letters surfaced. William Dowling, then McCrea's chief assistant prosecutor, started an investigation in McCrea's absence. When McCrea called to check in from Miami, Dowling explained the case to him. McCrea abruptly ended his vacation and hurried home by plane. The next morning, McCrea telephoned Dowling from his Detroit home and ordered him to stop the investigation.

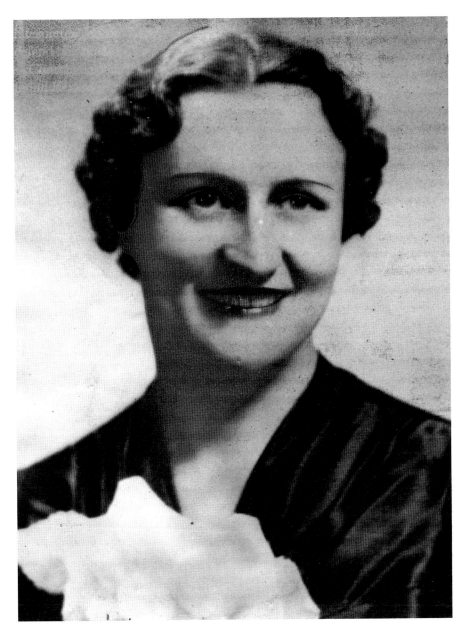

With her suicide and letter-writing campaign, Janet McDonald set off a string of investigations that toppled Detroit city government. *Author's collection.*

"He asked me what I was doing. I told him the charges were too serious to discuss over the phone," Dowling recalled later. "He wanted me to understand that the prosecutor's office was not an investigating body and he ordered me to stop. I was quite put out and I told McCrea I didn't think I could stop."

McCrea told reporters and city officials that he had a small staff and he did not want to use policemen as sleuths on the case. Moreover, he refused to be involved in a case that attempted to "whitewash the police department." As a result, McCrea rejected a request from Mayor Reading to review the evidence in the McDonald charge and, if the facts warranted, seek a grand jury investigation.

At least three groups asked the Wayne County Circuit Court for a grand-jury investigation. The court ultimately approved one brought by a group known as the Detroit Citizens League. A grand jury was considered the ultimate weapon, because it possessed subpoena power, unlike the state's attorney general's office. Michigan favored the grand jury in cases of political corruption in particular.

On August 21, 1939, Wayne County Circuit Court judges appointed a well-respected judge named Homer S. Ferguson to lead the investigation. Chester P. O'Hara, McCrea's former political rival, was named special prosecutor.

McCrea, who tried to attend the judges' meeting, was thrown out.

The Ferguson-O'Hara grand jury stated its purpose as investigating "gambling…and the possible protection thereof by certain officials of Wayne County."

"The newspapers pushed for an investigation. People were fed up with what was going on. The town was wide open. I supposed they felt that if this woman would kill herself and her daughter that something must be done," Ferguson later recalled.

If there was a man who could go toe to toe with McCrea, it was Ferguson. His belief in the law and an occasional poke in the nose was as legendary as his legal résumé. Once described as the "human buzz saw of interrogation," Ferguson was as tenacious as they come. "My father," Ferguson told one interviewer, "had a homely expression: 'A blind hog will find an acorn if he'll just keep his nose down.'" Ferguson was so concerned with blind justice that when he received the grand jury assignment, he resigned from the prestigious Detroit Athletic Club, because it was rumored poker was played there.

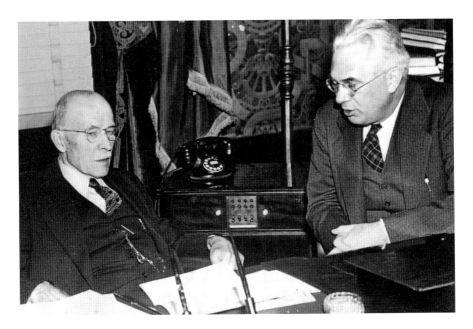

Circuit court judge Homer S. Ferguson (*right*) was tapped to lead a grand jury investigating charges of graft among Detroit's political elite. *Author's collection.*

His sense of righteousness also became lore. The most famous example of this came when Judge Ferguson punched a bail bondsman in the nose. Trouble began when the man suggested Ferguson "go easy" on a defendant. Ferguson adjourned the court and asked the bail bondsman to approach. "That's when I hit him," Ferguson recalled. "It was a reflex action. To think a man would try to fix you. I didn't regret it. I think it was better than sending him to jail. But I really didn't think he would bleed so much." The *Free Press* wrote an editorial about the incident: "There can be no reputation-wrecking gossip started about a judge who defends his integrity and detachment with his fists."

In the fall of 1939, Ferguson began the slow and painstaking work of a grand jury—collecting evidence, taking testimony and searching for answers. McDonald's letters were just the beginning. The biggest break happened when the Wayne County undersheriff turned state's evidence; this admission of wrongdoing created a domino effect. Small bagmen began talking. They involved others slightly higher up, and those intermediaries began to talk. Payments were traced to payoff men. Payoff men withered under the heat of the investigation. The investigation reached higher and higher, straight to the top of Detroit city government.

McCrea tried to impede the grand jury process time and again. He regularly impeached the grand jury in the newspapers, implying leaks in the investigation. In one scheme, McCrea tried to set up a seventy-one-year-old justice of the peace as a rival grand jury. At another point, McCrea even tried to start a fistfight between himself and Thomas A. Kenney, one of the assistant Michigan attorney generals assigned to the case. Another time, Ferguson was working late in his office in the former First National Bank Building on Woodward at Cadillac Square. "All of a sudden, I heard banging on the door," he recalled. "They were trying to break it down. I opened the door and I said, 'Gentlemen, there are no papers here. All of our records are in the bank vault downstairs.' And so they left." McCrea, who was leading the raid, later claimed he was there to investigate reports the grand jury was torturing witnesses.

On February 22, 1940, the grand jury handed down indictments against twenty-five individuals, including McCrea, his three chief assistants, former Superintendent Frahm and Sheriff Thomas C. Wilcox, a man known for wearing a diamond-studded badge he allegedly forced his staff members to purchase for him. The indictments alleged each had engaged in a conspiracy to protect gambling, prostitution and other forms of vice through the bribery of public officials.

Circuit court judge Earl C. Pugsley set a trial date of January 7, 1941. O'Hara told reporters this "was only a starting gun, and a pop gun at that."

No one was safe. That included Mayor Reading as well as his son, who served as his private secretary. The mayor earned the nickname "Double Dip Reading" because his bribes always had to include his son. Police inspector Raymond W. Boettcher told the court he took $2,000 in protection money every month from numbers men, carried it to room 2815 of the Book-Cadillac Hotel and gave it to the mayor. "I had a room there," Reading admitted, "but only for the purpose of keeping a change of wardrobe for attending social functions and taking a shower." The *Detroit Free Press* later summed it up nicely: "Reading subsequently took showers at Jackson Prison for three years."

Throughout the three-month trial, the testimony against McCrea grew more damning. McCrea decided he would defend himself in court. McCrea's erratic presence was anything but helpful. He was so belligerent that at one point he complained he got tired in the afternoons so he could not finish Ferguson's questioning during those hours.

The trial revealed long-standing criminal activity in the prosecutor's office. McCrea's role in the extortion racket allegedly began shortly after he

took office in January 1935. Witnesses testified McCrea had established an intricate system of graft collection from houses of prostitution, slot machine operators and game operators across Wayne County. By 1937, Sheriff Wilcox had set up his own payments from McCrea's sources. By 1938, Mayor Reading also was taking underworld money.

Gamblers, madams and kindred spirits apparently were paying money to all three sources for protection, the newspapers reported. Sam Block, McCrea's collection man, said the prosecutor's price was $100 to $300 monthly for a brothel, $100 to $200 for a handbook and $10 for each slot machine. Over McCrea's nearly five years as prosecutor, the court estimated his bribes added up to a total of $104,000.

McCrea was so disliked during this period that one of his assistant prosecutors, Glenn C. Hague, left his post in the prosecutor's office to join the grand jury. Another of McCrea's hires, William E. Dowling, went on to become a Ferguson staffer after testifying against his former boss. McCrea had fired Dowling on April 20, 1940, shortly after McCrea was held for trial for graft and conspiracy.

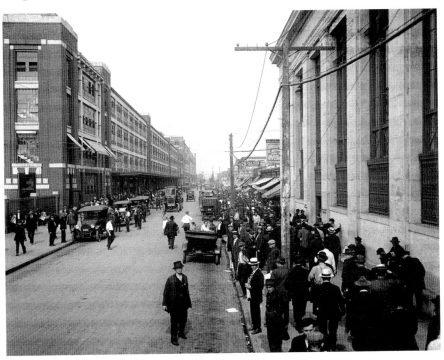

The Great Depression hit Detroit particularly hard given its dependence on the automotive industry, which was already prone to financial dips and layoffs. *Courtesy of the Library of Congress.*

During the grand jury, Ferguson asked Dowling why he had been discharged from the prosecutor's office. Dowling replied, "I was fired before I tried to carry out McCrea's orders to be honest, truthful and loyal."

"Did McCrea tell you to stop anyway?" Ferguson asked.

"Yes," Dowling replied. "It hurt me to be told to stop. I knew I was doing my duty."

The most damaging testimony came from Harry Colburn, who had served as McCrea's chief investigator when he became prosecutor. Colburn, one of McCrea's closest friends, had no experience in the law or law enforcement. Previously, he had worked in the wholesale fish business and as a tailor. Originally, Colburn was charged as a defendant in the case. However, he chose to plead guilty and testified as a witness for the prosecution.

O'Hara slowly worked Colburn over, causing the big man to snap his gum furiously to offset his nerves. "How did you handle the graft money for McCrea?" O'Hara asked.

"I generally did it in person and in cash and generally in McCrea's office," Colburn said. "The money was in cash, not even in envelopes. It was paid each month. [A guy] would give me the slips showing where the money came from and who paid it, but McCrea never looked at the slips. He would ask, 'Oh, keep those. It'll be all right. I'm not worried.'"

Colburn also testified McCrea paid him a visit during the trial. McCrea told him to pretend he was sick to avoid going into court.

"'You have got to do it,'" Colburn quoted McCrea as saying. "'It is the only thing that will save you.' I said, 'What am I supposed to do when these doctors that the court sends out come to examine me?' He said, 'You lay in bed, and you got pains in your back, and you got pounding in your head and you don't know what you are talking about. And if they become insistent, you get up and pound the wall with your hands, tear your hair out, tell them you don't know what they are talking about at all, that you get dizzy spells, that you can't stand up and you fell on the floor.'"

"I said, 'How long can I keep that up?'" Colburn said. "He says, 'As long as it is necessary. Months, six months, or a year.' He says, 'You will have a better chance later on than you will have now.'"

When O'Hara put McCrea on the stand, he asked his former colleague why he avoided a probe into the graft allegations. "I lacked sufficient investigators," McCrea said.

"Wasn't the real reason," O'Hara shot back, "that you had been taking dough along with other officers in the Detroit Police Department?"

As the city grew, the Detroit Police Department expanded in size to handle a rise in organized crime and mob violence. *Author's collection.*

"No," McCrea responded.

"Why were hundreds of gambling warrants found in bank safety deposit boxes owned by you, Mr. McCrea?" O'Hara asked.

"I don't recall," McCrea said.

On April 24, McCrea gave a four-hour closing statement in his case, claiming his personal collections man kept any money intended for McCrea for himself or gave it to Colburn to use. McCrea ended his rant by pleading with jurors to "forget and forgive" anything he may have said and base their verdict on the facts as he had pointed out to them.

In his closing statement, O'Hara reminded the jury of the seriousness of the charges before them. "I have no apologies to make to you…for the case we have presented here. We have attempted to bring to you the story—the true story—of what corruption went on between racketeers and public officials." O'Hara said he had no hard feelings against the former prosecutor. "I have no animosity in this case. I do not hate McCrea, as he would like to have you believe."

The Ferguson-O'Hara grand jury resulted in what one newspaper described as "one of the most sensational disclosures of municipal corruption in the nation's history." The jury brought in guilty verdicts against all but one of the 25 defendants. In total, 159 people were convicted. One estimate put the racket these men protected at an estimated annual worth of $30 million.

Reading told reporters as he left the courtroom the verdict was "the most inhuman thing since the Lord was crucified."

McCrea told reporters he was not defeated. "The verdict returned by the jury was not only contrary to the weight of the evidence, but to that of the law," he said. "I shall continue to fight for vindication to the highest court of the land, if necessary. I am confident that the verdict will be set aside."

McCrea held true to his word; he spent two years fighting his conviction. By this time, it was former prosecutor McCrea. Michigan governor Luren Dickinson had to forcefully remove McCrea from his job. Before he would serve a day of his sentence, McCrea took the charges against him all the way to the state supreme court. It ruled on November 25, 1942, to uphold McCrea's conviction for conspiring to protect vice and gambling in Wayne County. He now had to fulfill Judge Pugsley's sentence of between four and a half and five years in prison.

After his first-degree murder conviction, Bill Veres was an inmate in Jackson Prison. It is here that Duncan C. McCrea met with him upon his conviction in 1942. *Courtesy of the Library of Congress.*

McCrea, now inmate No. 55299, reported to Jackson Prison on April 12, 1943. Now, like the Witch, he was the one making headlines across the United States. McCrea arrived to sign in fit and tanned from spending time in northern Michigan as well as a six-week stay in Florida. In addition to his prison sentence, McCrea was looking at federal indictments on charges of evading tax payments on the income he collected from illegitimate sources as prosecutor. The federal indictment accused him of failing to report an income of $137,000 for the years 1937 to 1939, creating a tax bill of $20,903.

A few days after his arrival at Jackson, McCrea had settled in. He had a new job in jail as a clerk in No. 16 cellblock, which housed probationary inmates outside the main enclosure. He had some long-term plans he was ready to work on; he would find it was easy to do business behind bars.

But there was one more thing McCrea had to do.

On a bright spring afternoon, McCrea walked calmly across the courtyard in search of a face he had known in Detroit long ago. It took a few tries, but soon enough McCrea found the man he was after—a fellow inmate named Bill Veres.

7
A GROSS MISCARRIAGE OF JUSTICE

The Jackson State Prison yards are open spaces, roughly the length of a football field. Given the size of the prison and its population, it likely took Duncan McCrea several days to find Bill Veres. There is no record of their first meeting; no one will ever know what was said. What sort of conversation does a disgraced prosecutor have with the man he helped convict? And what would a man who loudly proclaimed his innocence say to the attorney whose actions resulted in his life sentence?

What is known is it was the first of many conversations between McCrea and Veres. In 1943, Bill Veres was going on twelve years at Jackson. He was a bewildered youth of eighteen when he entered; he was now a man of thirty. He had made himself useful in the prison, learning how to repair radios and other small electronics. Bill had left the prison only two times in his years there; both trips were to Detroit to see Rose.

McCrea seemed like a changed man when he befriended Bill.

"McCrea told me he thought I was innocent. He said he had been ordered to get a conviction. McCrea told me that the heat was on," Bill said of those prison meetings. "The last thing he asked me was: 'I hope you don't hate me.'"

Whether McCrea truly felt remorse or if his help was part of an effort to get revenge on an unknown party is a mystery. But McCrea went out of his way to speak on Bill's behalf, even going to bat for him with the parole board. McCrea's words not only served as a comfort within Jackson's prison walls, they also served as a beacon. After more than a decade behind bars, Bill had a reason to champion his innocence once again.

Another man wanted to see Bill redeemed before the court and the world. Bill's younger brother Gabriel was leading the fight for Bill's freedom. Gabriel was fifteen when his mother and brother were arrested, tried and convicted. Gabriel and John, then twelve, were put in juvenile facilities at first but ended up living with one of their mother's friends in the Delray area.

Their fight led them to seek an attorney who might have an open mind about the case. This couldn't be any ordinary lawyer. This person had to understand the law well enough to be able to defeat Wayne County's prosecutor. He or she had to believe in the story Rose and Bill had long held as true. Their courthouse savior had to be someone who could stand up to authority, knock on every door, search for clues in places where ordinary people feared to tread and do so with a limited—if any—budget.

Luckily for Gabriel, he found Alean B. Clutts.

In Detroit's relatively small legal circle, female attorneys were something of a rarity. Women who sought law degrees ended up working for family, taking on a smaller role within an established law firm or not practicing at all. There were a few examples of women who flourished in law despite these challenges. Alean B. Clutts was one of those success stories, forging her own path, operating a solo practice and building a solid reputation over the years for serving the underdog.

Alean Rose Brisley Clutts was born April 3, 1885, to Robert and Rose Fisher Brisley, residents of the waterfront town of Port Huron. Clutts had a pedigree for public service—her father was a city sanitary inspector and her grandfather a circuit court judge in Wisconsin once described as "the venerable judge of the North."

From an early age, Clutts believed in fair play. It was clear in her work with the American Red Cross, where she was said to lead one of the tightest groups in the city. It inspired her early years as a social worker. It was evident in her dealings with people of every walk of life; she treated men, women and children with dignity. When her brother Edward died unexpectedly of a heart attack in 1934, she and her older brother Frank took care of Edward's six children alongside his widow, Louise, like they were their own. Clutts visited them so often in Port Huron that the social pages of the local newspapers highlighted her many trips.

She married Joshua K. Clutts when she was twenty-four. Joshua was a sizable man with a square jaw and barrel chest. In census rolls, Josh Clutts is

listed as a laborer or automotive worker, likely taking up one of the many positions on the assembly lines across Detroit. It was hot, physically demanding work, the kind that sent a man home exhausted and hoping for a warm meal with his wife. But in the case of Josh Clutts, his wife likely was out running some meeting, rallying for a cause or helping out with another political campaign.

Clutts spent much of her early married years volunteering for social concerns, such as the Sisters of Charity, which focused on orphans and unmarried mothers. During World War I, Clutts was a member of the Grindley Arcade Red Cross, described in one local newspaper as "one of the liveliest units in the city" of Detroit. Her work with the Red Cross earned a variety of accolades in the newspapers, including

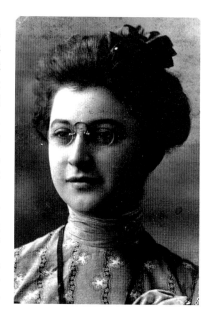

Alean B. Clutts was a crusader for justice from a young age, helping the American Red Cross and participating in local elections. *Clutts family collection.*

one write-up that heralded her leadership as well as the fact that the nurses in her group were "very, very pretty."

Clutts also was politically active, serving as a volunteer on a variety of committees for luminaries such as Senator James Cousens and Senator Charles E. Townsend, serving as vice president of Townsend's campaign committee when he first ran for office. It may have been these interests, combined with her well-defined sense of justice, that resulted in a new ambition. In 1923, Clutts became a student at the University of Detroit, where she would study the law in hopes of becoming an attorney. While there, she fully engaged in school activities, social events and legal sororities, even at age thirty-eight.

Although photographs of Josh and Alean together appear to show a congenial relationship, those looks were deceiving. During their marriage, Josh reportedly abused Alean both physically and mentally. He was seen around town taking other women to shows and dances, the local newspaper reported. Things came to a head on July 18, 1924, when Josh knocked Alean off of the telephone and threw her across the room. According to the divorce proceedings, Josh admitted his wife was

"too refined" for him. Alean sought a divorce in 1925, citing cruelty and physical violence. It was at this time she started to be known in her public life as Mrs. Alean B. Clutts, taking on her maiden name as her middle initial, as was custom in those days.

She was admitted to the bar in 1926. The *Port Huron Times Herald* noted her achievement, adding, "Not too many women come to public service and higher learning after having started the career of a wife." Her goal, Clutts said, was to study criminal medicine, the "social problems of the unmarried mother" and "the dope situation."

"A woman must round out her education if she is to be of service to the world," Clutts told reporters.

She established her offices in the Penobscot Building, where she would be a tenant for more than twenty-five years. Her work as a solo practitioner was impressive enough. But she also held many firsts in the legal community, including being the first female attorney in the city of Detroit to be appointed to the grievance committee. In 1930, she was admitted to the United States Supreme Court.

Cases other attorneys passed on because of the time involved or lack of payment seemed to always land on her desk. In 1929, Clutts obtained the release of Mrs. Helen E. Walker from Eloise, a psychiatric hospital in Northville. Walker's physician husband had had her arrested, taken to Receiving Hospital and committed. Clutts successfully argued that the woman, a forty-one-year-old nurse, had demanded counsel while in the hospital and was refused the right to meet with an attorney before being committed. Two years later, Clutts sought the release of seventeen-year-old Wreatha Baker, who was sentenced to five years at a training school for disobeying her mother. Clutts argued that disobedience does not constitute a crime and the girl was never given "her day in court."

Both Harry S. Toy and Duncan C. McCrea had battled Clutts— and lost. Clutts came up against Toy when she argued a case on behalf of thirty-one-year-old Robert Nickens, who was convicted of violating the state narcotic law. Nickens saved his cigarette allowance for more than a year to buy a law book. He found a discrepancy in the law that could shorten his prison term and wrote a letter to Clutts for help. She won him a new trial.

Clutts won a new trial for Ned McSherry against McCrea in what a circuit court judge called a "gross miscarriage of justice." In the McSherry case, he had been found guilty of robbing a Wyandotte beer garden while on parole from Jackson Prison, where he had served a sentence for a similar

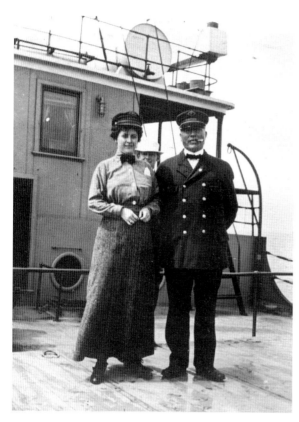

Left: Alean Clutts married her husband, Joshua, when she was in her mid-twenties. It was a rocky relationship. *Clutts family collection.*

Below: Alean Clutts (*center*) remained closed to her brother during her stormy marriage to Joshua Clutts. *Clutts family collection.*

offense. His first trial ended in a jury disagreement. The second brought a guilty verdict, but he was granted a third chance when a juror told the judge he had voted guilty only so he might be free to go to a doctor's appointment. After his third trial, McSherry was sentenced to serve four years to life in Jackson Prison. Convinced of his innocence, Clutts began her own investigation. She found a man named Willard Long, also a convicted robber, and helped him file an affidavit while he was in prison. "Two of the men who had parts in the robbery came to me and told me about it," Long told reporters. "They were worried for fear that McSherry might be convicted of a crime in which he had no part."

Clutts began meeting with the Veres family in the summer of 1943, shortly after McCrea talked to Bill at Jackson Prison. Her primary contact in these early months was Gabriel Veres, Rose's middle son. Around this time, he and John were living together as roomers in a house on Harrington Street. Gabriel, who likely dropped out of school after his mother went to prison, was working as an assembler in an automotive factory.

When he wasn't working or watching out for his youngest brother, Gabriel studied the trial. He had read the transcripts multiple times, focusing on John Walker's testimony. He told Clutts the thing that stuck in his mind was how the two unnamed defendants, John Doe and Richard Roe, were never found. Then, on November 15, 1943, Gabriel ran into Mike Milne, who had testified against Rose and Bill. Milne told Gabriel he had testified under the name Mike Ludi, acting as a witness for the prosecution. Those words gnawed at Gabriel. Walker had mentioned Ludi as helping with Mak's death—he could have been one of those unnamed defendants. Yet neither Ludi nor Milne were charged.

Clutts met with Rose Veres for the first time on September 7, 1943, in the women's division of the Detroit House of Correction. Clutts wanted to see for herself whether Rose could speak English, doubting the transcripts of Walker's testimony from the trial. Clutts tried to chat with Rose, only to find herself stymied at every turn. Everyone at the prison, from the warden to the doctor to Rose's direct supervisor, said they never spoke to Rose in English beyond a handful of words.

Once the seeds of doubt about Rose and Bill's guilt had been planted, Clutts was committed to taking on the case. In November 1943, Clutts notified the court she was the new defense attorney for Rose and Bill Veres. In a short letter dated November 16, 1943, to recorder's court clerk E. Burke

Alean Clutts (*far right*) divorced Joshua Clutts (*bottom*) in 1925 after he was said to have abused her. He said she was "too refined" for him. *Clutts family collection.*

Montgomery, Clutts wrote: "My dear Mr. Montgomery: Will you please be good enough to file the enclosed Appearance in [*People v. Veres*, No. A-1314]. I shall appreciate it very, very, very much. Cordially, Alean B. Clutts."

It is uncertain why the court separated the two cases at this time, selecting Bill as the first defendant to come before the court and ask for a new trial. But in December 1943, Clutts had filed a motion with William E. Dowling, the Wayne County prosecuting attorney, to grant Bill a new trial in recorder's court.

Dowling—the assistant prosecutor who had testified against Duncan C. McCrea before the grand jury investigation—had succeeded his former boss. Dowling became Wayne County prosecutor in 1940 after serving for

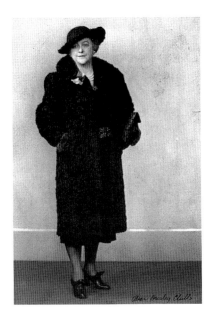

Alean Clutts was a rarity among female attorneys, successfully running a solo practice from the late 1920s through the 1950s. *Clutts family collection.*

a short time on Homer Ferguson's staff to help direct McCrea's prosecution. The Liverpool, England native became a lawyer at age twenty-nine, graduating from the Detroit College of Law. He became an assistant prosecutor in 1935, working alongside his then-boss McCrea on the city's infamous Black Legion trial, bringing the post-Depression era organization akin to the Ku Klux Klan under heel. He had seen the highs and lows of Detroit, having lived through the June 1943 Detroit race riot, which pitted black against white and ended in the deaths of thirty-four people.

In her motion for Bill's request for a new trial, Clutts outlined half a dozen reasons why the young defendant deserved another day in court. Two areas of her motion struck the court as worthy of consideration. In the first, Clutts said there was no way the state's star witness, John Walker, could have recalled lengthy conversations with Rose Veres—Rose could not speak English well enough in 1931 or currently to have talked for that long and at that level of comprehension. In the second, the court seemed intrigued Clutts had found a state witness named Mike Ludi who might have been confused with another man, specifically Mike Milne, a former boarder in the Veres home. Ludi, who had testified against Rose and Bill, indeed could have been either "John Doe" or "Richard Roe" as outlined in the prosecutor's initial arrest warrants, Clutts alleged, and therefore he should not have been before the court as a witness in the case.

Clutts wrote in her deposition: "Deponent says that she is fully convinced, by her investigation, research and study of the testimony, that by reason of the conflicting testimony on the part of the People's witnesses, the errors complained of, the newly discovered evidence and the fraud practiced upon the Court by the Prosecution, the conviction of the defendant Bill Veres was a gross miscarriage of justice, and that he should be granted leave to file a Motion for a New Trial."

READING THE COURT testimony was one thing; hearing the truth from a man's lips was another. Clutts began visiting witnesses from Bill's 1931 trial. One of those calls was to Detroit police officer Earl Switzer. Clutts phoned him on March 3, 1944, shortly before a hearing of her motion for a new trial. Clutts wanted his take on whether Rose could speak English well enough to carry on a long conversation with John Walker. In 1931, Switzer had testified Rose could not speak English, so he had passed on interviewing Rose back then.

After a few pleasantries, Clutts asked Switzer what he remembered about the case.

Switzer said he could not get a word out of Rose when he tried to get her to talk. The Veres case, he noted, had stuck with him, even after all of these years.

"Thank God my conscience is clear in this case; that's what the rest of them can't say," Switzer told her.

ON MAY 18, 1944, Clutts walked into Judge Thomas M. Cotter's courtroom on Bill Veres's behalf. She argued that new evidence showed Rose Veres could not have carried on extensive conversations with John Walker and cast doubt on Walker's testimony in regard to Bill.

Given the circumstances, Judge Cotter said he would grant Bill Veres a new trial. The victory was significant. Bill—who had lived for the past thirteen years at Jackson Prison—was returned to Wayne County Jail to await his new trial.

In its written opinion, the court shed serious doubt on Bill's participation in Mak's injuries or death. "It was apparent from the record that there was a doubt in the Court's mind about Bill being present when the defendant Rose Veres made the alleged statement to Walker," Judge Cotter wrote. "If he wasn't there when she made that statement, it certainly was not admissible. It was probably one of the most damaging parts of the testimony as far as Bill Veres was concerned. I think that without that in the case, it is a question just how far the people would have gotten. That being so, I believe that is the basis for a Motion for a New Trial."

In the weeks that followed, Dowling privately met with Whitman and other Detroit homicide detectives to go over the case. Whitman laid out the facts as he knew them: The woman did not speak English. There had been no blood at the scene. Witness testimony conflicted. The few witnesses still alive would be tough to find, let alone agree to testify. Whitman told Dowling Bill Veres had served his time—and then some.

On May 31, 1944, the doorbell rang at Alean Clutts's office. Clutts was out, so her secretary answered the door. On opening it, the secretary discovered George M. Stutz standing there. Stutz asked politely if he might come in, and the secretary agreed. He asked if he might review the transcript of the testimony in the 1931 trial of Rose and Bill Veres. The secretary agreed. As he sat reading, Clutts returned. She immediately recognized this visitor to her office. She asked why Stutz was interested in this particular case, especially one from so long ago.

"I was anxious to refresh my memory as to the testimony in this case for I have never worried so much about any case as this one," Stutz told her.

In his opinion, Stutz said, Kenney did little to refute the state's case on Rose's behalf. He added that Kenney was no match for "dynamic McCrea." He paused, but something made him continue.

"When I saw how weakly the case was being defended, and how much inadmissible testimony was being put in by the Prosecutor without any objection from the defense counsel, I felt as though ice water was running down my back," Stutz admitted.

Did she know, he asked, that the Rose Veres case had been his to handle? Did she know he told Prosecutor Toy the case was, in his opinion, very weak? Did she know Toy took the case from him and assigned it to McCrea? And did she know he was told to assist McCrea in creating a case? Stunned, Clutts admitted she did not.

Stutz admitted to Clutts he had spent "100 hours" trying to get an expression in English from Rose Veres without success. He said he was surprised when the jury came back with a guilty verdict, and he believed Judge Cotter felt the same way. Stutz offered his help to Clutts in the hopes of getting the mother and son a new trial.

The drive to Jackson State Prison from Detroit is nearly two hours, so Clutts had time to consider what she might say to Duncan C. McCrea. He had been in jail for a year now following his graft conviction, so he may have mellowed in terms of admitting his misdeeds. Or, more likely, the former prosecutor may have hardened, making any chance at conversation regarding Bill and Rose Veres difficult, to say the least. Still, Clutts was hopeful when she arrived at the prison on June 10, 1944.

Without hesitating, McCrea spilled his guts.

In his mind, McCrea said there had always been a doubt about Rose's and Bill's guilt. He explained to Clutts he had told his chief the case was weak.

McCrea said he asked for four groups of investigators to help him, but he was given only two.

The chief told McCrea to get a conviction no matter what and to put the heat on in this case.

In his opinion, McCrea said Rose and Bill were poorly represented. At the time of the trial, McCrea did not know Mike Milne and Mike Ludi were the same man—the so-called butcher that allegedly helped beat Mak and throw him from the attic window. If they were the same person, McCrea said it was highly improper for the state to use Ludi as a witness. Because the defense counsel did not call his attention to the mistake, McCrea said he was unaware of the fraud he may have committed.

BILL VERES AND Alean Clutts had a hearing with Judge John P. Scallen on June 13, 1944. Behind the scenes, something big had happened. That morning, Dowling submitted to Detroit Recorder's Court what is known as a *nolle prosequi*, or a formal notice of abandonment by a prosecutor of all or part of a suit or action. He was asking the court to let Bill Veres out of prison.

"Officers of the Detroit Police Department's Homicide Squad have made a thorough investigation of the facts, and have been unable to locate many witnesses who testified at trial, which occurred approximately 13 years ago. In view of the fact that these witnesses cannot be located, and that the defendant Bill Veres has spent over 13 years in jail, we ask that this case be nolle prossed," Downing wrote. "Inspector John O. Whitman, who was in charge of the Homicide investigation for the Detroit Police Department at the time of the original prosecution, along with Officers Harry Gaide and Dewey Hughes of the Homicide Squad, concur in this nolle prosequi."

Back in the courtroom, Chief Assistant Prosecutor Julian G. McIntosh started the proceedings. Neither Bill nor Clutts had entered the room yet. McIntosh opened the hearing by asking Judge Scallen to dismiss the murder charge against Bill.

As his words echoed through the courtroom, sheriff deputies brought Bill inside.

Judge Scallen granted the motion.

Just then, Clutts walked into the courtroom. Bill caught a glimpse of his defense attorney from the corner of his eye. The deputies who had been guarding him left his side. A man who had been watching the proceedings took Bill's hand and shook it vigorously. Bill, politely taking the hand of the passerby, stood in bewilderment as Clutts joined him.

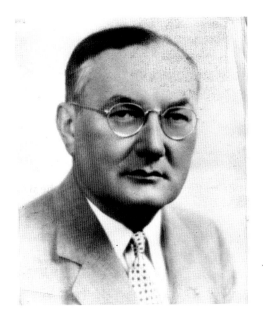

Judge John P. Scallen dismissed the charges against Bill Veres, freeing the man after thirteen years in prison. *Author's collection.*

He asked her one question: "What happened?"

"You're free," Clutts said, seemingly as shocked as her client. "You don't have to go back to prison."

Bill shook his head, as if clearing a longtime fog.

"What do I do now?" he asked.

Gabriel, who had been in court the whole time, moved forward and put his arm around his big brother.

"We'll help you," he said.

OUTSIDE OF THE courtroom, a few reporters who had attended the hearing circled around the newly freed man. Bill, unaccustomed to such a spotlight, talked with an unabashed sense of awe at this unexpected moment.

"Right now, I want to see my mother again," he said. "She's in the hospital out there. She doesn't seem to be very well."

Bill also revealed his prison confidant, Duncan C. McCrea, and how the disgraced prosecutor had helped him. He recounted McCrea's plea: "I hope you don't hate me."

"Hate him," Bill repeated, a smile growing across his face. "I don't hate anybody. I'm so glad to be free that I love the world."

8
ANOTHER DAY IN COURT

Buoyed by her victory with Bill Veres, Alean B. Clutts prepared for her next mission—she would get Rose Veres a new trial. With the same evidence she used in Bill's case, Clutts felt certain she could obtain her freedom. The facts were the same: Nothing but circumstantial evidence linked mother and son to the death of Steve Mak. Rose's motive was flimsy, considering Mak's insurance policies expired before his fall. And only the questionable testimony of John Walker held the case together. Given the relative ease with which Bill was released, Clutts had reason to believe her path would be smooth.

However quickly Bill Veres found freedom, the opposite would be true for his mother.

The fact was, Rose Veres's was an altogether different case than that of her son. He was Bill Veres, a misguided youth, a son who was easily influenced. Rose, on the other hand, was the "Witch of Delray" to the public, the press and the rest of the world. She was a mass murderer of as many as twelve men. She hexed all she encountered, from neighbors to police officers to prosecutors. Moreover, in the eyes of the law, Detroit Recorder's Court and Wayne County, Rose had received a fair trial.

Clutts could not have known then that her mission to free Rose Veres would take her down nearly every road in Delray, deep into Rose's secret life and two years to see to its end. But, just as it always had throughout her life, Clutts gave in to her sympathies for a woman, a widow, a mother. It likely meant ignoring other cases to track down interviews. It certainly

would cost her in terms of taking on more lucrative work. But it also could prove the most important case of her life, and Clutts never met a lost cause she didn't like.

With Bill, Gabriel and John at her side, Clutts began to research Rose's life in earnest. The language barrier was considerable; even with a translator, Clutts found it difficult to connect with Rose. Rather than give up, Clutts decided to dig further. She knew Rose was innocent, so there had to be other reasons why Rose was found guilty that fateful October day. Something or someone put Rose Veres behind bars for more than a decade. Clutts was certain an intense investigation into every aspect of the 1931 trial and the people involved would prove Rose deserved freedom.

At the end of Bill's trial, Clutts stated her intentions clearly: She would now seek the freedom of Rose Veres. By doing so, Clutts stirred up a beehive of activity. Prosecutor William Dowling declared to the newspapers on June 16, 1944, that he was ordering a thorough inquiry into Mak's 1931 death, the Veres trial and Rose's life.

On June 23, 1944, Dowling sent Assistant Prosecutor Edward A. Elsarelli to the Detroit House of Correction; his mission was to determine whether Rose Veres could speak English well enough to communicate with the outside world.

Elsarelli arrived with Assistant Prosecutor John G. Balose, who was fluent in Hungarian. Despite having Balose at his side, the conversation with Rose started poorly.

"Who speaks Hungarian, Rose?" Elsarelli asked.

"Mary Axenberger, and the girl," Rose said.

Elsarelli replied, "Why is Mary Axenberger here? What did she do wrong?"

"Me no care what other girl do; me got no friend," Rose said.

"Don't you feel well?" Elsarelli asked.

"No, me side," Rose said. "Call Mr. Gilles, telephone. Get Hungary girl."

Elsarelli tried to distract Rose from calling in another translator. "How many children do you have, Rose?"

"Me got four children; one girl, three boy."

"You work every day?" Elsarelli asked.

Rose smiled. "Me work," she said. "Me drink, mister?"

After a glass of water, Elsarelli went on. He asked Rose where she lived in the prison, whether Bill came to visit her and Bill's age. Rose answered

each question in short sentences. She also asked repeatedly for a doctor. The prison's psychologist, Dr. Maurice Floch, was brought in to continue the conversation.

At one point, Elsarelli asked where Rose had been during Mak's fall. She said she was at a restaurant, getting bones for her dog. She named people who saw her there at the time of his fall. Rose told the assistant prosecutor she had told her defense attorney, Frank M. Kenney Jr., about it at the time of the trial, but he thought it was not necessary for her to use her alibi. Rose also said Kenney told her not to take the stand at her trial because she did not have to do it.

After talking to Rose and prison officials, Elsarelli made up his mind: Rose had been perfectly competent to stand trial then and didn't deserve a new one.

"There is no reason at this time why leave to file a motion for a new trial should be granted," Elsarelli said in his affidavit. "It is [my] conclusion that Rose Veres is sufficiently conversant with the English language to have been able to convey to John Walker the things that John Walker testified to.…If it is true that Rose Veres has not spoken any more English than is set up in the affidavits of defense counsel at this time, or that she has not carried on any conversation in the English language during her 13 years of confinement, then she has apparently done an excellent job of 'playing possum' during that period of time."

Elsarelli's affidavit angered Clutts. In her rebuttal, Clutts said his statements "show clearly that the Prosecution is still self-satisfied with its inconsistent theories and inconsistent attempts at proof of the manner in which the alleged crime was committed." Moreover, it offered only fragments of Elsarelli's three-hour interview with Rose. A portion of the interview took place in English, but the majority was done in Hungarian through the aid of at least two interpreters, Clutts wrote. That Elsarelli's word—likely taken out of context to prove his theory that Rose could speak perfect English—could be taken above that of Rose's longtime jailers was preposterous.

Newspapers were the unofficial "thirteenth juror" in Rose's 1931 trial, Clutts also alleged. Clutts said the jury was not locked up nor cautioned not to discuss the case nor read newspaper accounts of the proceedings during the trial. The "sensational and circulation-minded press" published "imaginary and fictitious libels" regarding Rose, and these "wholly false, inflammatory, vicious and malicious distortions" skewed the testimony in court and, thus, the jury's minds.

Walker's testimony also contradicted itself, making his words false and perjured, Clutts wrote. The witness told Officer Earl Switzer he had "run and looked and seen" Mak falling from the ladder. Later, Walker said he had come up out of the basement, looked at the attic window and "out came the man and hit the house over there, head first from the window in the second story."

Alean Clutts filed a motion for a new trial for Rose Veres on Thursday, July 13, 1944. She began searching for experts to disprove the state's theory that Rose and Bill could have beaten Mak, carried him upstairs and thrown him from an attic window. Clutts needed three things to get her motion for a new trial approved: new evidence, courtroom errors and fresh witnesses.

On August 9, Clutts sent certified mechanical engineer Boyd V. Evans and a co-worker to the former Veres home on Medina Street. After visiting, measuring and examining the home, Evans said, "the John Walker testimony was impossible of accomplishment." Just exploring and photographing the attic was like taking his life into his own hands, Evans said.

"Assuming that the deceased man was unconscious, the defendants would have to drag or carry him across the basement, up a stairway, through the kitchen into the bathroom, a distance of approximately 50 feet," Evans said.

> Upon entering the bathroom, which measured 6' x 6'4", defendants would have to carry the deceased up a six-foot ladder through a trap door in the ceiling measuring 2'2"x2'10" to the attic, thence across exposed floor joist, a distance of 14'6" to a partition dividing the attic; thence through an opening in said partition, said opening measuring 18" wide and 16" high and 22" above the floor joist.
>
> Thence a minimum distance from the opening in the partition of 36 feet across the exposed floor joist past obstructing electrical wiring to the window, from which it is alleged the deceased was kicked out. Had the deceased been helpless from the alleged beating, it would have been impossible for the defendants to carry or drag him across the aforesaid area of the exploded floor joist without the defendants or their victim falling or slipping through the ceiling, and it is further concluded…that had the deceased been conscious, a struggle would have ensured the same results.

CLUTTS FOUND DR. Daniel L. Harmon on the faculty of the University of Detroit, where he was a professor of physics and director of the department of physics. For more than twenty years, Dr. Harmon had taught physics at various educational institutions. Clutts gave him John Walker's testimony to review.

On September 18, 1944, Dr. Harmon visited the former Veres residence at 7894 Medina Street and went over the alleged route. "The steps from the basement are in two flights at right angle turns," Harmon said. "The bathroom is very small and the trap door in the ceiling is so situated that one must enter the room and close the door from the inside to approach the ceiling opening."

"The attic has no flooring and the lath and plaster ceiling of the rooms below is attached to the lower edges of the joists," Dr. Harmon said, which was a typical way to build a home. "This means that one has to remain on the upper edges of the joists in moving about the attic since a force of a few pounds would break through the ceiling. The low rafters make it necessary for a grown person to crouch considerably in moving about in this attic. The hole through the wood partition has its lower edge 22 inches above the joists, and is 18 inches wide and 16 inches high."

"Basing my unbiased and disinterested opinion upon what I have read and seen, I would say that the testimony of this John Walker is unreasonable, and that the operation described is impossible of attainment. I make this assertion after…deliberate consideration."

If Mak had been conscious, he could have fought their efforts at any time, Dr. Harmon said, especially on the staircase or in the bathroom. If he had fought at all in the attic, the low height likely would have caused some damage to the ceiling there. But there was no testimony to any damage to the attic ceiling at all, nor was there any visible to Dr. Harmon. Even if Mak had been unconscious, the plan as Walker described it could not have been carried out. Mak's body was described as weighing 160 pounds, Dr. Harmon said, and he would have been limp and unable to move if he were unconscious.

"The size of the bathroom precludes the possibility of the four people and a ladder being squeezed in with the door shut and leave any room for motion sufficient to perform the task of lifting Mak through the ceiling," Dr. Harmon said.

One person on the ladder could scarcely carry the body to the top of the ladder, and certainly could not direct it through the hole two feet above the ladder if he could exert sufficient strength to elevate it to the hole.

Detroit's population had topped one million by 1931, the result of an earlier influx of immigrants and the start of the southern migration for factory jobs. *Courtesy of the Library of Congress.*

One or two people above, then working from the edges of the joists, would have to reach down a foot or more though the hold and draw the body up, this being done in the limited working space and with the necessity of preventing even one blow on the plaster. This mean that arms, legs and head of the limp form would have to be completely supported at all times along with the weight of the torso. This problem of protecting the plaster is present during all operations carried out in the attic.

But the hole in the partition presents a definite block to the scheme. Two people on one side, and one on the other would have to support the dead weight higher than 22 inches above the joist while performing the practically impossible task of pushing or pulling a body that size through a hole so small. Due to the size and location of this hole, a man 160 pounds would have a difficult time willingly crawling through.

ONE MAN STOOD between Clutts and Rose's freedom: Judge Thomas M. Cotter, a judge who prided himself on never having one of his cases reversed by a higher court.

On September 26, 1944, Judge Cotter refused to let Harmon and Evans testify. The court ordered the prosecutor's office to file affidavits in reply to Clutts's plea. Judge Cotter adjourned the hearing to October.

A few weeks later, the case changed again. Judge Cotter died unexpectedly of a heart attack on October 15, 1944. A new judge would need to be assigned to the case.

AFFIDAVITS CAME IN quickly on November 14 and 15, 1944. There was Joe Yando, an assistant manager of a Delray furniture store. He knew Rose Veres for nineteen years and, in that whole time, had never heard her speak the English language. Then there was Sam Kohlenberg, another furniture store employee who had known Rose for fifteen years. The same went for Joseph Gegus, a hardware store owner who had known Rose in Europe before they arrived in America; at no time did Rose ever speak English to him or anyone else he observed. The same was true for Julius Fodor, owner and editor of the *Hungarian News*, and Alex Leichtman, owner and manager of a clothing and furnishing store. Mary Chevela, who had lived across the way on Medina Street for nineteen years, never, even in neighborly chats, heard Rose speak English. Ditto neighbors Mary Nagy and Julia Szabo. Rose only spoke Hungarian to all of them.

So why was Walker the only person who heard Rose speak in English?

With Cotter's death putting the case up in the air, Clutts filed a motion for a new trial. Shortly before Thanksgiving 1944, Judge John J. Maher was assigned to review the request.

Her motion came in with ten points for Judge Maher to consider; her affidavit was double that length. In her review of Rose's trial, Clutts was blunt. First, Steve Mak's death was the result of an accidental fall, not an assault or as a result of wounds from a deadly weapon. Second, John Walker had committed perjury when he claimed Rose and he had carried on extensive conversation in English. On the contrary, Clutts noted, 1931 trial testimony as well as numerous new affidavits prove Rose could not speak English then and could not speak the language in 1945, either.

Clutts took on the legal issues next. She claimed Rose's trial was a gross miscarriage of justice. One item that stood out to her was when Judge Cotter did not let the jury hear Dr. Ryan say Mak's injuries were sustained from a second-story fall, which could have caused his death. Clutts also didn't like that the court allowed the state to enter the other insurance policies found in Rose's home into evidence over Kenney's objection; Clutts found that a highly prejudicial error. The prosecution failed to produce any deadly weapon; there was testimony from Dr. Isadore Shapiro there was no evidence of a blow to the head; Detective Snyder testified there were no bloodstains around the attic, first floor or basement. Clutts also believed via her affidavit that Walker's testimony was "pure fabrications," since he said his conversation with Rose took place entirely in English. Perhaps he wanted to get rid of his landlady, once and for all.

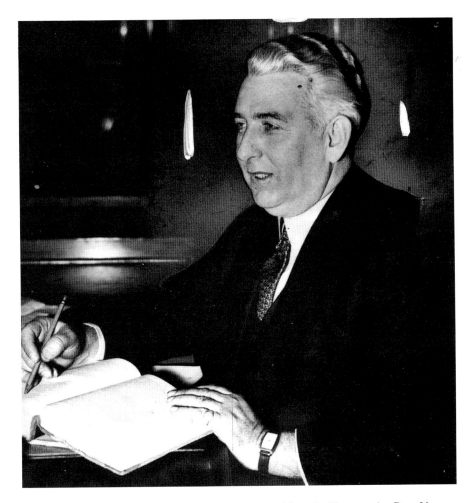

Judge John J. Maher initially denied the request from Alean B. Clutts to give Rose Veres a new trial. She had to bring a state supreme court decision in to have him acquiesce. *Author's collection.*

The final straw, Clutts alleged in her motion, was that the state had known its witness, Mike Ludi, was under suspicion as a accomplice to Mak's death—he was the "John Doe" listed on Rose and Bill's arrest warrant. Putting Ludi—also known as Mike Milne, or the "Butcher"—on the stand to testify against Rose was fraud, Clutts alleged.

Around the same time, Clutts ran into Stutz again in court. There, he cemented her resolve.

"In my opinion," Stutz said, "those defendants did not have their day in court."

It wasn't enough. Despite Clutts's allegations of errors and new evidence, Judge John J. Maher denied the motion for a new trial on December 20, 1944.

In his five-page response, Judge Maher agreed the state's theory that Mak was beaten in the basement, dragged upstairs and pushed out of the window was, indeed, bunk. However, he noted John Walker did not come up with that theory; he only said Rose told him that story. The jury knew there were two theories as to how the alleged crime occurred, the judge wrote, and they were more than capable of determining the facts of a case. Additionally, the prosecution did not have to prove Rose's motive after mentioning her interest in Mak's insurance money. And, as the final nail in the coffin, Judge Maher said the court "does not place much credence" in the claim that Rose could not speak English. She hired an English-speaking attorney, didn't she? And there is no affidavit from Frank M. Kenney Jr. that his former client could not speak or understand English back in 1931.

"This court shares the opinion of Mr. Balose and Elsarelli when they state in substance that the defendant is 'playing possum' and is guilty of deception and camouflage," Judge Maher wrote.

However, the judge gave Clutts room to file additional affidavits or other steps to fortify her motion. In her response, Clutts decried Judge Maher's decision and called him out for misunderstanding portions of the proceedings as well as confusing newspaper reports with court testimony.

Infuriated, Clutts continued to search, question and interview until she found the material she needed.

It was a call no defense attorney wants to receive—Bill Veres needed Clutts to come with him to the Detroit Police Department.

Bill and Clutts arrived at police headquarters on January 15, 1945, and were sent to the detective bureau. It seemed word had gotten out on the street that Bill and Gabriel Veres were searching for jurors from the 1931 murder trial.

Whitman greeted the two politely and escorted them to a small interrogation room. He set their minds at ease—this was a friendly warning.

"It might have been better if you had left the matter of questioning a juror in the hands of your attorney," Whitman said, his gravelly voice consolatory.

He paused.

"But if she were my mother, I would do everything possible to establish her innocence," Whitman said. "I would have probably done just what you did."

Clutts met with Edward C. Schaub, foreman of the jury during Rose's original trial, in hopes of getting an affidavit from him as well. Her goal was to find out what had happened that day in the jury box and see if she could find a few more cracks in the case.

In their interview, Schaub was like an open book. He told Clutts the group of potential jurors was practically exhausted because of the number that were excused. They told the court they had enough exposure to the case through the *Detroit News*, the *Detroit Free Press* and the *Detroit Times* as well as via radio broadcasts that they knew more about the case than a citizen might otherwise.

Schaub said the trial judge also commented on the run of jurors in the case. The judge more or less said the jury would have to come from the remaining people in the room regardless of their exposure to the case. If he excused any more jurors, Judget Cotter said, the court might have to go out on the street to find a jury, Schaub recalled

The jury foreman told Clutts about how impressed the jurors were with McCrea. In his closing arguments, the assistant prosecuting attorney stressed the testimony of John Walker in his case. Walker, McCrea reminded the jury, had knowledge of how Rose and her son had beaten Mak to the point where the man was nearly incoherent. The dastardly duo then took him up through a trapdoor in the ceiling of the bathroom into their attic, where they threw him bodily out of the window. It sounded horrific, and it made an impression on the jury.

Inside the jury room, Schaub said opinions ran heated. People's thoughts were scattered. "He must have been conscious to make it possible for [Rose and Bill] to get him up in the attic," one remarked. A few jurors started going over their trip to Rose's house a few days before, where they had gone into her tiny bathroom to examine the opening in the ceiling where Mak was said to have been pushed. One juror asked if anyone had gone up the ladder in the bathroom, perhaps to try to recreate the journey up into the attic. No one had. But a few of them remembered going partially up the ladder, which was placed against the outside of the building.

The conversation became particularly heated when the jurors started to dissect John Walker's testimony, Schaub said. He knew as foreman that much of the case would rest on Walker's shoulders. If the man was telling the truth, Mak had been brutally beaten and murdered that hot August day. If Walker were lying, then they had to question everything the state told them about the case. Schaub looked from face to face, each one expressing worry and doubt. But one thing seemed clear to him: The jury

as a whole believed Walker's testimony and accepted the means used to bring about the death of Steve Mak.

CLUTTS KNEW SHE had one more major hole in the case to fill. She had to find Kenney, and she needed a statement from the defense attorney. But finding a man who doesn't want to be found isn't as easy as it sounds. Clutts asked around Detroit's legal circles. What had happened to the disgraced lawyer? Where had he gone?

She hit pay dirt when someone brought George F. Curran to her attention. Curran, a Detroit attorney of some note, met with Clutts on March 7, 1945, to give an affidavit about the last time he had spoken to Kenney.

In September 1944, Kenney was in town from New York, and he wanted to get together with Curran. The two men set up a time to talk, meeting at a place on Washington Boulevard.

Kenney asked his old friend whether Curran knew anything of Alean Clutts, who was stirring up new interest in the 1931 case. It seemed, Kenney noted, Clutts was something of a legal eagle, getting Bill Veres released after so long. Curran said he did know her a bit in passing.

Pausing, Kenney admitted he did not want to become involved in Clutts's business. But if Curran wanted to pass along a message, tell Clutts that during the time Kenney had known Rose Veres and represented her, he had never been able to talk to Rose in English. It had always been through an interpreter.

Let her know that, Kenney said.

CLUTTS FELT LIKE she was circling closer and closer. She arrived at the Detroit House of Correction on March 3, 1945, and waited in the consulting room for Rose to arrive. She took her longtime friend and Port Huron native Homer D. Alverson with her in hopes of bringing some good luck.

The attorney began by greeting Rose warmly, inviting her to sit down. One more time, Clutts started talking to Rose in English. The two tried to carry out a conversation, but Rose became mixed up quickly and her frustration grew. Thinking quickly, prison superintendent Grace Travis sent for an interpreter. A fellow Hungarian inmate arrived, and Rose calmed down so they could continue.

Clutts started her questioning again. Had Rose ever talked to her first attorney, Frank M. Kenney Jr., in English? No, Rose said through the

interpreter, she and Kenney never had. In fact, Rose never hired Kenney to defend her at all.

Clutts looked at Alverson out of the corner of her eye. Who, Clutts asked, found Kenney and hired him to defend you?

A man—and old friend—Joseph Gegus of Delray. After Gegus hired him, Kenney came to see her in the county jail. These visits were the only time Rose talked to Kenney at all about her case. A Hungarian inmate interpreted their conversations. Rose added she never talked to any attorney in English.

Clutts, sensing Rose's willingness to talk, asked the question she had been waiting to ask for months now: What happened at her Medina Street home that Sunday afternoon?

Rose finally told her side of the story. Mike Ludi— the butcher who roomed in her house—and Mak were in the basement. Rose had asked them to fix a broken attic window. The two were arguing over who should do the work. It was a common argument, and Rose didn't stay to hear the end of it. They'd argue over anything, and neither one wanted to work if they could help it.

Rose said she left the house to go to a nearby restaurant; the owner there often gave her discarded food to feed her dog. As the restaurant workers got the bag of scraps together, Rose sat on a stone in the rear of the place. That is when John Walker and a neighbor woman came up to her and told her Steve Mak had fallen off the ladder. Rose jumped up and ran through the alley to the gate, where she saw Steve lying on the ground.

If you didn't push him, Clutts asked, then why did you have the insurance policies on him?

Rose laughed. She told Clutts she had never collected any insurance on her boarders. One man had died leaving $400 for his burial, and Rose had used the money exactly for that purpose.

But what about the large sums of money people said Rose had collected over the years through those insurance policies?

"Nuts," Rose said through her interpreter. "I was on welfare."

Finding Joseph Gegus a second time wasn't difficult; he was more than willing to talk to Clutts about his old friend. He came to her office on March 8, 1945. Clutts immediately peppered him with a list of questions: Why did Gegus hire Kenney? What did he know about Rose that made him extend such generosity?

The first thing Clutts needed to know, Gegus said, is any story about Rose being a woman of means was ridiculous. Gegus said he knew all the

stories—tales of how Rose had accumulated considerable money through dishonest methods, and that the whole neighborhood was talking.

Gegus said the truth was something altogether different. At the time of her trial and conviction, Rose owed him $4,897.13, a debt that was still unpaid. That total was the amount of money Gegus paid to save Rose's property from foreclosure in 1929. He also paid $400 in back taxes. He had resold the house back to Rose on land contract so the widow could stay there with her three boys. In fact, Gegus had paid the mortgage on her house since then because Rose was unable to make the payments. Rose also owed his hardware and furniture store $314.97 for materials used to repair her home.

Clutts asked him why he would allow Rose Veres or any customer to carry such bills.

Rose was working hard to raise her children in a respectable manner under difficult circumstances, Gegus said. Rose was an honest woman, he added, and if people had known this about her, she would not have been the victim of "a cruel miscarriage of justice."

Gegus said he went to Rose's house after he heard of Mak's fall. He found Detroit police all over the property, so he pulled one aside.

"Do you believe this is a case of murder?" Gegus said he asked.

"No," was the officer's reply.

CLUTTS WANTED TO find Frank M. Kenney Jr. And this time, Kenney wanted to be found.

On March 8, 1945, Kenney sat before an attorney in Syracuse, New York, to give an affidavit about his participation in the 1931 trial of Rose and Bill Veres.

In his affidavit, Kenney explained he had known Rose Veres for about two years before agreeing to take on her murder trial. From when he was hired to her day in court, Kenney said Rose's English vocabulary was limited to two words: "hello" and "goodbye." In all of the times Kenney met with Rose to prepare for trial, he had to use an interpreter "because it was absolutely impossible to converse with her without" one. Moreover, finding a consistent interpreter was nearly impossible.

"Due to the wide and unfavorable publicity given to the case, the neighbors who volunteered as interpreters would act once and would then be scared away by other neighbors, who were prejudiced against the defendant," Kenney said. "At no time was [I] able to check on the

interpretation given by interpreters but had to rely on them to tell the truth and properly interpret conversation. This was extremely difficult."

Kenney had one final bone to pick. Judge Maher, he believed, should consider the current motion for a new trial in part because of the 1931 trial's massive publicity.

"[I] made a motion before the Honorable Thomas M. Cotter at the inception of the trial of [Rose Veres] to lock up the jury during the pendency of the trial due to the wide and unfavorable publicity given to this trial by both the newspapers and radio," Kenney said. "But that the Honorable Court denied the motion of counsel and allowed the jury to return to their homes each day after the close of the daily session; that it is this deponent's sincere belief that the jury was swayed by this publicity; that the defendant's rights were prejudiced."

In a cover letter to Judge Maher, Kenney said he hoped his attached affidavit might be of help to the judge in "rendering a just decision" on behalf of Rose Veres's request for a new trial.

"It has always been my sincere personal opinion that this whole case was ballyhooed and turned into a field day for the newspapers by a then very ambitious Assistant Prosecuting Attorney," Kenney wrote.

"It is my sincere opinion that with the wide and unfavorable publicity given to this case the defendant was convicted before she ever stepped in Court before a jury; that this case was nothing more than a Roman holiday for said Assistant Prosecuting Attorney; that the defendant was the bystander who got hurt."

9

"NO, I DIDN'T KILL HIM"

I n 1943, the Michigan Supreme Court made a significant ruling in a case called *People v. Little*. In it, a man accused of statutory rape asked for a new trial because the judge as well as his attorneys were not in the courtroom when the verdict came in. In the original *Little* trial, the court clerk had accepted the verdict and released the jury. The following day, the conviction was entered into the court records.

In Little's motion before the state supreme court, his attorneys successfully argued that having a court clerk accept a verdict instead of a trial judge opened the door to possible irregularities. How Alean B. Clutts heard of *People v. Little* is uncertain. What is certain, however, is how she used it.

Clutts appeared before Judge John J. Maher on April 6, 1945, with a fresh plan on how she would get Rose Veres a new trial. Clutts brought court reporter Chester A. Stickel, who worked for deceased Judge Thomas M. Cotter, forward to testify.

Stickel told the court the jury in the 1931 trial of Rose Veres had returned its verdict at 9:22 p.m.

"Do your notes show that the Court was present?" Clutts asked.

Stickel replied: "My notes show definitely that the Court was not present. I have a note there, 'Court not here.'"

Bingo.

On April 12, 1945, Clutts turned in an amended motion for a new trial. Clutts simply wrote that Judge Cotter was not in the courtroom when Rose's and Bill's verdicts were read.

Now, it was the court's turn.

On April 13, 1945, Clutts and Assistant Prosecutor Martin Paulsmo met with Judge Maher. The magistrate cut to the chase.

"I find that this case was tried by a jury and the late Judge Cotter, and as far as I am able to tell, without error. I have checked and examined with case the 10 or 15 reasons listed for a new trial. I find all of the said reasons to be without merit," Maher said.

The courtroom was silent.

"Except," Maher added, "the one which deals with the receipt of the verdict in the absence of the Court."

"The case of the People Versus Little…is quite broad, and in substance states that the rendition and the receipt of the verdict is a judicial proceeding, and the Court's presence is necessary and it cannot be waived ever by stipulation to be taken in the Court's absence," Maher said.

"And the motion for the new trial, therefore, is granted in the case of the People Versus Rose Veres."

The audience—and Clutts, for that matter—gave a collective sigh. Judge Maher, sensing the change within his courtroom, addressed the elephant in the room.

"Every effort should be made by the Prosecuting Attorney authorities to retry the case, since this new trial is granted only on what might be termed as a technicality and not on any real basic merit," Judge Maher told Paulsmo. The assistant prosecutor assured the judge he would have a new team of detectives assigned to the case. Judge Maher also noted he felt he should not handle the case, given his knowledge of the first trial.

Clutts, desperately holding her tongue, finally spoke.

"Well, may I say that it is my sincere wish that the Prosecutor will decide to retry this case," Clutts said. "I do not feel today that there is any glory whatever in Rose Veres being granted a new trial on a technicality."

When Rose Veres went into the Detroit House of Correction in October 1931, she was a mother to three young sons. She not only lost a first-degree murder case, she also lost her house, her livelihood and her reputation. When she stepped back into the courtroom in November 1945, she was a sixty-four-year-old grandmother with years of hard time under her belt. She still wore a widow's black garb, but her hair was now white as snow.

Detroit had changed as well. Mayor Edward J. Jeffries Jr. was preparing to lead the city into a "golden era" of new growth. Jeffries, the son of Recorder's Court judge Edward Jeffries Sr., had stepped up to lead the city

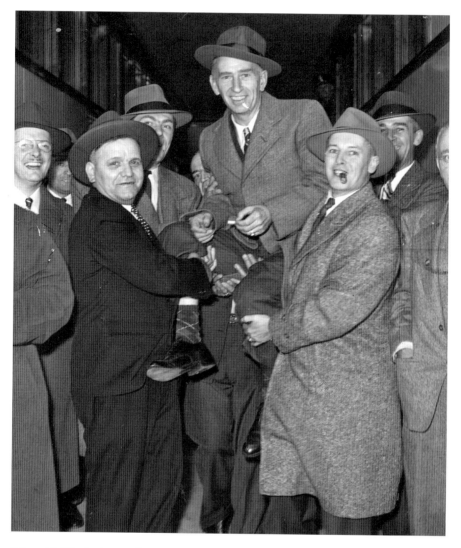

Edward Jeffries Jr. became Detroit's mayor in 1945 and established a plan of urban renewal for the city that eliminated areas such as Black Bottom. *Author's collection.*

after Mayor Reading was put in jail after his graft conviction. Jeffries Jr. was in the midst of preparing what he would call the Detroit Plan, an urban-renewal proposal that was as ambitious as it was controversial, tearing down areas, including Black Bottom, for a new freeway.

The nation had changed rapidly as well. President Harry S. Truman now led the country following the death of Franklin D. Roosevelt in

April during an unprecedented fourth term. Stories about Nagasaki and Hiroshima, VJ Day and promises of a new international prosperity dominated the headlines.

The Witch, in some ways, was old news. The *Detroit Free Press* relegated news of her jury selection to page fourteen that day.

As Clutts prepared to go into court, she had a new judge to consider. Rose's retrial came before Judge Paul E. Krause, a recorder's court officiant who was considered empathetic and scholarly. The Cleveland native served in World War I, graduated from the University of Michigan and served as a law partner to Mayor Jeffries. Governor Harry F. Kelly appointed Judge Krause to the post in 1944. Although he was relatively new to the bench, Judge Krause had already seen his share of cases, lawyers and newspaper reporters. He knew how to handle his courtroom.

The retrial of Rose Veres began on November 27, 1945. On the first day, Clutts had an equal share of wins and losses. Judge Krause denied her motion to lock up the jury for the trial's duration. She also lost a motion demanding Assistant Prosecutor John A. Ricca bring in all of the original exhibits in the case, including the ladder Mak allegedly used as he climbed up to repair an attic window. Ricca told the judge he would make an attempt to locate the ladder. Luckily for Ricca, Krause demurred when the defense demanded all of the exhibits, remarking that retention of these objects in criminal cases would require an enlargement of Detroit's police headquarters.

Still, Ricca had other challenges in front of him, one being the search for the 1931 trial's witnesses. Many of them had moved, either out of the state or even the country. Of the original twenty-two state's witnesses, four of them had died. In all, Ricca told the court he planned to call fifteen witnesses; Clutts said she would bring forward ten.

Ricca was well known to the court, having served for more than a decade in the Wayne County prosecutor's office. Ricca, a short man with a wide jaw, was considered a straight shooter. He had worked some of Detroit's biggest cases as an assistant prosecutor. To the public, Ricca was best known for working alongside Duncan C. McCrea on the infamous Black Legion trial, successfully putting seven people away for murder. His photos, usually beside McCrea, were in the newspapers on a regular basis. But according to most reports, Ricca's associations with McCrea ended there.

Jury selection also went quickly. A group of five men and nine women were selected for the retrial; this total included two substitute jurors. This was a twist from Rose's first go-round, when the jury consisted of eight men and four women.

Ricca opened the state's case on November 27, 1945, with John Walker. Walker, now fifty-three, took the stand with relatively the same story as he had when he first testified against Rose. The morning of August 23, 1931, seemed like every other except when Walker noticed a ladder leaning against Rose's half of the home against an attic window. Walker moved it, afraid the neighborhood children could be hurt if it were to fall. Walker told the jury Rose made him help her put it up again. She then told him to sprinkle water on the ground around the ladder.

Walker was returning home from taking the hose to the neighbor who owned it when he looked up and saw Steve Mak hurtling out of the attic window—the same window against which the ladder had been placed that morning. Mak landed on his back, Walker testified.

"After Mak hit the ground, I saw Mrs. Veres, wearing a little white cap, snatch her head back inside the window," Walker said.

Moments later, Walker said, Rose joined him at Mak's side. She then poured a basin of water over Mak's face. Mak's head was severely injured, Walker testified.

"She told me she would get $4,000 insurance if the old man died," Walker testified. "She held her finger to her lips and told me: 'Don't talk and you'll get $500 and won't have to pay any more rent.'"

That night, Rose and Bill bragged about beating the "hell out of Mak," Walker said. They beat him in the home's basement, took him upstairs to the attic and pushed him out of the window, Walker said. During this conversation, Rose repeated her offer of $500 and free rent for his silence.

Clutts got up to cross-examine the witness. It started with hostility. Walker refused to tell Clutts his address or where he worked. Judge Krause stepped in and asked why he would not answer the defense attorney's questions.

"Mrs. Veres has three grown sons, and I'm afraid of what they might do to me," Walker told the judge.

Testimony resumed on November 29, when Bessie Hill took the stand for the prosecution. Hill, who had been a renter in the home across the street from Rose, told of how she heard a noise coming from outside of her home. She looked up and saw a box, nails and tools falling from the window. She heard another noise, but did not investigate.

Ricca read Hill a portion of her testimony from the 1931 trial, refreshing her memory of when Rose came into her home. Hill back then had testified that Rose had come in asking for a basin of water and a towel. According to her testimony then, Hill had said Rose used these items to wash her face, arms and hands after beating Mak and pushing him out of the attic window.

To Ricca's surprise, Hill denied this part of the story entirely. Hill, perhaps having second thoughts about her original testimony, answered "I don't know" several times when Ricca asked if her previous statements were correct.

Judge Krause stopped Hill's testimony. He removed the jury from the room. At Ricca's request, the judge spoke sharply to the woman.

"I am not accusing you of telling an untruth," Judge Krause said to Hill, "but I want to impress upon you that this is a murder case. I'm going to read to you the statute on perjury, and I want you to go home tonight and think over what you have testified to today."

Ricca brought Medina neighbors Walt and Mary Moore to the stand next. Both testified they had heard a hammer, nails and a saw hitting the ground just before Mak's body came flying out of the attic window. Mary Moore added she became terrified when she saw Mak come out of the window like that, so she ran back into her home across the street.

The court adjourned for the day. Outside the courtroom, Ricca ignored questions of whether he planned to recall Hill to the stand when the trial resumed.

ON FRIDAY, NOVEMBER 31, Ricca had the testimony of a witness from Rose's first trial read into the court record. George Halasz had died in July 1933, but he was a key witness to Mak's fall, Ricca said. In his original testimony, Halasz said he was visiting the Veres home on August 23 to see an old friend, Mike Ludi. As he stopped in front of the house, Halasz said, he saw Mak through the attic window and heard him cry out.

According to Halasz's testimony, Mak said, "Don't touch me. What are you trying to do, kill me? Don't kill me."

Rose replied, "Shut your mouth," according to the witness.

That is when Mak plunged from the attic window with his left side forward. Rose was pushing him from the right side, Halasz testified. He also said he saw Rose's head, covered with a white cap, at the window as Mak fell. He said he had not seen Mak climb the ladder from the outside of the Veres home.

Mike Ludi was next on the stand. Through a translator, Ludi testified he arrived home to the Veres house around noon on August 23, 1931. Rose gave him three glasses of whiskey; Mak received one, Ludi testified. He also said he heard Mak and Rose discussing life insurance. Afterward, Ludi fell asleep and awoke suddenly when he said he heard Rose shouting. "Mak has

fallen from the ladder," he claimed Rose said. Ludi testified he ran outside and saw Mak lying on the ground, a pool of blood at his side.

The next witness was Julius Macker, a salesman for the Life Insurance Company of Virginia. According to his testimony, Rose made payments on two $300 life insurance policies Mak had on August 22, 1931. However, he added that Rose was not named as a beneficiary on either of the two policies. On August 25, two days after Mak's fall, Rose again paid Macker the premiums on Mak's two policies for the next two weeks. At the time, Macker told the jury, Rose told him Mak had fallen from a ladder but said he "wasn't hurt much."

Upon cross-examination, Macker admitted to Clutts he had sold many policies to Delray women for their roomers and that the women often paid the premiums.

The court called a recess.

JUDGE KRAUSE BROUGHT the jury back in on Monday, December 3, to hear one more version of Mak's fall from its youngest witness. Rose Chevala Kasa was only eleven when she testified to seeing Mak fall from the attic window. Now twenty-four, Kasa said she was playing in the sand across the street from Rose's house when she saw Mak climb the ladder to the attic window, carrying a box that he dropped on his way up. He then disappeared into the window. Four or five minutes later, she saw Mak come flying out of the attic window headfirst, strike the side of the house next door and fall to the ground.

"He was moaning when he fell," Kasa said. "His head seemed to have been hurt."

FOR CLUTTS, THE biggest testimony came on December 7, 1945. The courtroom felt electric as Clutts brought Rose Veres to the stand to testify before a jury of her peers.

Speaking through an interpreter, Rose Veres denied putting a ladder against the side of her house. She also denied that she saw Mak fall. She denied that she had made alterations to her home's attic. And, finally, she denied that she had offered John Walker a $500 bribe to keep his mouth shut.

Rose admitted she paid some premiums on Mak's life insurance. "If a man isn't home when the collector comes, it's customary for the landlady to

pay it," she told the jury. When Mak would arrive, he then paid her back, Rose testified.

At her attorney's questioning, Rose added she did not know whether Mak had named her as the beneficiary on any of his policies.

It was now Ricca's turn. Under cross-examination, Rose repeated her denial that she killed Mak and her claim that she was seated by a neighborhood store when neighbors informed her of Mak's fall.

Ricca asked, "Did you push Steve Mak out your attic window?"

"No," Rose replied.

Ricca asked again. "Did you kill him?"

"No, I didn't kill him," Rose said.

In his closing arguments, Ricca told the jury Mak's death was "the most vicious and best-planned killing I have ever handled."

Clutts told the jury her client was a victim of persecution at her initial trial in 1931.

The case went to the jury on Monday, December 10, 1945. Jurors received the case shortly before 10:00 a.m. and returned their verdict eight hours later. Rose Veres, they said, was not guilty.

Rose panicked. She thought the foreman said "guilty" and fainted after the verdict was read.

Upon being revived and told she was free, Rose said through a translator, "My God, I thought they were going to send me back again."

Clutts was humble in her post-trial comments. "I have always been confident and positive that Mrs. Veres was innocent," she said.

10
FAREWELL, DELRAY

Facing reporters outside the courtroom, Rose through her sons told the newspapers her first wish was to visit her husband's grave. All of those years locked away had prevented Rose from paying her respects to Gabor. Gabriel told reporters he would take his mother to see him soon. Through a translator, Rose said it had been a long fight for freedom, but now she was happy.

Bill, Gabriel and John explained to reporters that as a family, they would stand by their mother and help her reintegrate into society. Always the family spokesman, Gabriel explained that John and he had saved to pay the expenses of Bill's retrial. When Bill was released, he then joined them in pooling their money to cover the costs of freeing their mother. All three boys praised Alean B. Clutts not only for taking on the case, but also for allowing such a payment system to exist.

Years later, the *Detroit Free Press* asked Judge Krause to recount some of his more infamous cases. He brought up the Witch of Delray and her retrial. The key to the jury finding her innocent, Krause said, was going to the Medina Street house to inspect the prosecutor's theory of how Mak might have died in August 1931.

"I took the jury out to the scene," Judge Krause recalled. "They looked over the house and, in particular, the route over which the prosecution contended Mak's body had been dragged to the attic window. Mak was a heavy man. The jury believed it was physically impossible and found Mrs. Veres innocent."

IN HOPES OF living quietly, the Veres boys left Delray. They moved to Melvindale, a nearby Detroit suburb. There, the brothers lived only a few miles from one another. Rose primarily lived with Gabriel on Wall Street. Bill became a machinist at Solvay and lived on Henry Street. John was around the corner on Flint Street. Bill often described his mother as still possessing the "unflagging energy" that marked her earlier years. She took up knitting, often nagging her sons for more material. She also learned how to play bingo, a pastime that bordered on obsession.

The one thing that Rose wanted to do most, however, was to earn her U.S. citizenship. She applied to become an American in August 1948, when she was seventy years old. Despite the months in court, the years in prison and the decades of grief she experienced, Rose still wanted to honor the place she now called home by becoming a full citizen. Maybe it wasn't the life Rose had envisioned when she came to the United States from Hungary. But it was the life she was given, and Rose was determined to live the remainder of her days with dignity.

Shortly after her retrial, Senator Perry W. Greene told local newspapers he hoped to introduce a bill in honor of Rose Veres at the special session of the Michigan legislature. It would recompense persons unjustly imprisoned and later pardoned or acquitted. There is no evidence Greene's bill made it through the state legislature. There is no evidence Rose or Bill received any compensation for spending more than a decade in prison. They likely did not receive any help of any kind after their incarceration. Like most people, Rose and Bill were expected to figure out on their own how to find a job, how to reintegrate into society and how to live with the specter of being the "Witch of Delray" and what newspapers had described as "her mentally challenged son."

What made their lives even more challenging is that newspapers regularly brought their names and stories out on a regular basis. Years after their conviction, news articles told of how Rose's ability to hex people had brought about the death of a man who testified in her 1931 trial. John Kampfl had tried to live a normal life after Rose and Bill went to prison, the *Detroit Free Press* wrote, but her "powerful evil eye" prevented him from having any peace. He slashed his own throat and died not because of his own actions but because of Rose's witchcraft. "There was no use trying to live once the 'mark' fastens itself," the reporter alleged.

John Whitman retired from the Detroit Police Department in 1956 and moved to Pennsylvania, where he became a justice of the peace. *Whitman family collection*.

JOHN WHITMAN RETIRED from the Detroit Police Department in March 1949. He received multiple promotions during his thirty-five-year career with the force, completing his time there as the deputy chief of detectives. He worked on hundreds of violent cases, many more than a gentle man cared to remember. Much of the time he worked he also spent mourning his daughter, who died in December 1931 of pneumonia. Losing Aurelia took some of the color from his life, and he continued to pay tribute to her through his passion for gardening.

John and Carrie Whitman retired to Gettysburg, Pennsylvania, to be near her family and enjoy the rest of their days. They lived near former president Dwight Eisenhower's farm; the great man was said to visit the local courthouse from time to time. Whitman, who found it hard to be away from law enforcement, ended up appointed as a justice of the peace in 1956. Those who knew him said Whitman upheld the law with honor and respect.

ALEAN CLUTTS ACCEPTED the accolades for Rose's trial, but she was already working on other cases. She gained national attention in 1949 when she won a pardon for Maude Cushing Storick, who was serving a life sentence for the alleged poisoning of her former husband, Claude Cushing. Claude was a well-known figure in Dowagiac, a northern Michigan city. He frequently used bicarbonate of mercury as a throat gargle despite warnings against it. Claude died in January 1922, and the attending physician attributed his death to "stomach complaints and heart trouble." Shortly after Claude died, Maude married a former bus driver and resort owner named Emory Storick. Rumors began to fly following her quick remarriage, claiming Maude had had something to do with her first husband's death. Local officials exhumed Claude's body, tested his organs and found he died of mercury poisoning. Maude Storick was arrested in August 1922 and convicted of first-degree murder on March 17, 1923. She was sentenced to life in prison.

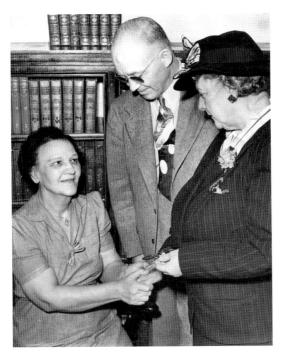

Left: Alean B. Clutts defended and successfully gained release for Maude Cushing Storick, who had served twenty-seven years for a murder she did not commit. *Author's collection.*

Below: The Storick family, including Emory Storick, worked closely with Alean Clutts to defend Maude Cushing Storick in her search for justice. *Author's collection.*

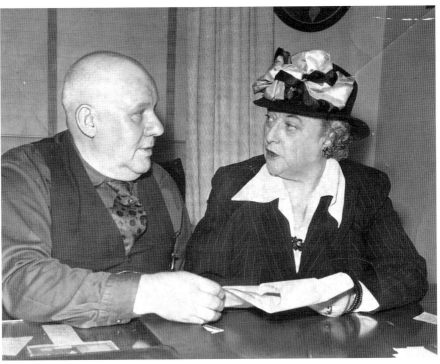

Over the years, many people tried to help Storick with her appeals—including her original jurors. Eight members of the jury that convicted her filed a petition in 1931, asking that her sentence be commuted because she had been convicted on circumstantial evidence. That same year, 146 residents of Cass County petitioned for her freedom. Clutts heard about the case and agreed to look into it. The transcript for Storick's trial had been lost, and Clutts started her work with only the statements of the convicted woman and her loyal second husband.

The case turned into a four-year endurance test. But Clutts was ready for it, spending countless hours gathering evidence, making telephone calls and meeting with Maude and Emory and their three children. Clutts told one reporter the case required her to "scrape the bottom of the barrel." At one point, the parole board offered to commute Storick's sentence and release her with time served. Clutts refused the deal because it implied Storick was guilty. She took Storick's case before Michigan governor G. Mennen Williams, and he pardoned the woman and proclaimed her innocent of the charges against her. The sixty-six-year-old Storick had spent more than twenty-five years in prison for a crime she did not commit.

"I never seem to get these cases when the people first get into trouble. Only when they're in trouble and others have been unable to help have I been fortunate to be able to help them," Clutts told the *Times Herald* in Port Huron. The newspaper noted that to compile all of the lawyer's accomplishments "would be to write a book."

ROSE VERES WOULD not recognize Delray as it is today, and it does not remember much of her. The "Witch" is only known as a character, perhaps a fiction told to scare children into behaving. She is talked about in comical ways, as if her "evil eye" might still be potent. Veres is nothing but a ghost to them. Every once in a while, a bar names a drink after the Witch of Delray, taking a bit of Detroit lore and turning it into a Halloween special.

The few scraps of her life that remain are sidewalks in front of where her house once stood. Otherwise, her block of Medina Street is a shadow of its former self. The once-dense rows of houses and alleyways have been torn down; only two poorly maintained houses remain. There is no evidence Rose Veres ever lived there. In fact, the lot where Steve Mak received his life-ending injuries is now empty.

Delray itself no longer resembles anything from its storied history. The area that once enchanted Huron and Algonquin tribes for its beauty, access

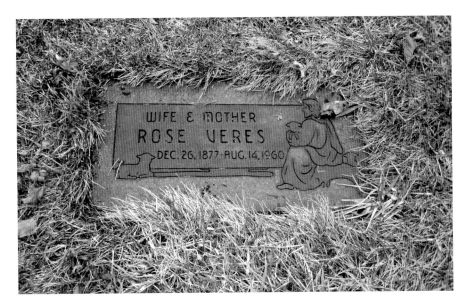

Rose Veres is buried next to her beloved husband, Gabor, at Woodmere Cemetery, which is located just outside of Delray, off of Fort Street. *Author's collection.*

to food and natural barriers at the juncture of the Rouge and Detroit Rivers is no more. Gone are the ribbon farms the French planted in the place they called Belgrade. The land that charmed Augustus D. Burdeno enough that he named it after a scenic spot in Mexico where he served during the Mexican-American War has been stripped of its former character. The open spaces where Detroit held its 1889 International Exposition and drew thousands to the city and its entertainment are contaminated and barren. The beloved village that once was Detroit's fastest-growing suburb with houseboats along the river, maple trees lining its streets, outdoor beer gardens and a steady flow of Hungarian immigrants has disappeared almost entirely.

Rather, it has become a dumping ground for heavy industry. As the size of its factories and waste-treatment plants grew more important than the residential areas, Detroit changed the zoning from largely residential to commercial. It felt like another indication the city wanted to forget the place where so many Hungarians formerly called home. Today, the air is rank and filled with a heavy chemical smell that seems to cling to your clothing as you drive through the neighborhood. Many houses are derelict and stand empty. Vacant lots cover most of the neighborhoods. Storefronts are barren. Delray, for all intents and purposes, is dead to the rest of Detroit. A few loyal families and longtimers remain. Otherwise, most of the environment is so

polluted that those who stay complain of headaches, nausea and asthma. At one point, the Sierra Club sited the Delray community as one of the most polluted areas in Michigan. Small changes started with the announcement of a new international bridge set to be built in Delray, but they come after decades of neglect.

The once-rebellious village of Delray is only remembered by those who study maps or come across the occasional article about Detroit's history. They may know of Delray because of a dusty picture hanging on a bar wall. It could be from an article explaining Detroit's explosive growth during the early part of the 1900s and how it annexed Delray against its will. It could be a tiny mention in a story about immigration or a remembrance of the sizable Hungarian population that once lived there. But these references aren't easy to find; one has to search them out in library archives or history museums.

The only physical reminder of the Rose Veres case and its legacy is a simple hat: a Dobbs Fifth Avenue straw Panama hat from Hughes and Hatcher with a snap brim and a light-brown patterned band. It sits under a cracked plastic cover on a wooden stand outside the offices of the Wayne County prosecutor in downtown Detroit. A now-faded newspaper column

hangs over it, featuring *Detroit Free Press* writer Neal Shine. Shine tells the story of Duncan C. McCrea and his fall from grace in 1940, the result of the largest political scandal in Detroit history. To avoid arrest, McCrea left the office so quickly that he left his hat behind.

McCrea's hat hangs in the prosecutor's office to this day as a reminder. It is a reminder that the law matters. It is a reminder that whoever occupies the prosecutor's office "should be able to leave with their pride and dignity intact" and with enough time to put your hat on before you go, former prosecutor John D. O'Hair told Shine.

Duncan C. McCrea's hat, which he had to leave behind when he was run out of the prosecutor's office, remains in the Frank Murphy Hall of Justice as a reminder of his misdeeds. *Author's collection.*

It is a reminder that the prosecutor is supposed to focus not only on justice but also on protecting every citizen under his or her jurisdiction—including those who are accused of a crime.

EPILOGUE

Steve Mak died on August 25, 1931. He is buried in an unmarked grave in the oldest section of Parkview Memorial Cemetery in Livonia.

Rose Veres died on August 14, 1960. She spent her waning years knitting and playing bingo. She is buried next to her husband, Gabor, in Woodmere Cemetery, just outside of Delray.

John O. Whitman died on November 27, 1965, of a heart attack. During his time as head of the homicide bureau (1929–45), the bureau became recognized for "its proficiency in solving crimes of violence and murder," the *Detroit Free Press* wrote. He retired as the deputy chief of detectives and was recognized by his superiors as "the best homicide officer Detroit ever had." He retired in 1949 after thirty-five years of service. He held nineteen precinct citations and one departmental citation.

Alean B. Clutts died on February 28, 1964. She is buried at Mount Hope Cemetery in Port Huron. She continued to practice law after her success with freeing both Rose Veres and Maude Cushing Storick. Those two cases became her legacy, and Clutts received numerous accolades for freeing both women. She became an outspoken opponent of capital punishment. Her memory is still beloved by her grandnieces and nephews.

Frank M. Kenney Jr. died on December 29, 1947, at his home in New York. All known records show he never practiced law again after 1937 and may have been a manufacturer's representative.

George M. Stutz died on January 2, 2002, at age one hundred. During his long and significant career, Stutz also served as president of the Old

Newsboy's Goodfellow Fund, was elected to the board of governors of the Jewish Federation of Metropolitan Detroit and was a founder of Temple Israel, where he was president from 1947 to 1949. He received the coveted Fred M. Butzel Award from the Jewish Federation of Metropolitan Detroit in 1975. He also received the Jewish Historical Society of Michigan's Leonard Simons History Award in 1993.

Duncan C. McCrea died on May 25, 1951. He was disbarred from legal practice for life in 1944. But he went on to run a successful business, which he built up while in prison. He also tried to run for city council to replace Edward J. Jeffries Jr., but the city and the circuit court ruled that his graft conviction barred him from the ballot.

Harry S. Toy died on September 9, 1955. He was elected attorney general in 1934 and served until October 1935, when he was elevated to the Michigan Supreme Court, where he served until 1936. He also was police commissioner of Detroit, an office he held from 1947 to 1950. He was planning a run for Michigan governor when he had a heart attack.

Homer S. Ferguson died on December 17, 1982. Ferguson was a Wayne County Circuit Court judge from 1929 to 1942 and was a Detroit College of Law professor from 1929 to 1939. He also was elected to two terms in the Senate, served as ambassador to the Philippines and sat as a judge on the U.S. Military Court of Appeals.

Chester P. O'Hara died on February 14, 1964. O'Hara, described by the *Detroit Free Press* as "one of Michigan's most respected jurists," succeeded Ferguson as Wayne County Circuit Court judge. Called "immensely popular," O'Hara received the largest number of votes in the circuit bench's 1959 election and became an executive judge. He and Ferguson were instrumental in the 1944 shakeup and cleanup of the Detroit Police Department.

William McBride died on November 11, 1939. Janet McDonald's so-called unworthy lover passed away from pneumonia. He did not live to see the end of the grand jury investigation or to pay for his role in it. The former newspaper boy born in Corktown was buried in Lansing.

Vera Brown died on March 10, 1976. Brown worked at the *Detroit News* from 1918, two days after her graduation from the University of Michigan, to 1930 and at the *Detroit Times* from 1930 to when it closed in 1960. "She never let a fact get in the way" of a good story, Jack Crellin once said of Brown. She was known as the "Flying Reporter" as Michigan's first female commercial pilot. She wrote thirteen novels and won the Ernie Pyle Award for her wartime columns in 1947. For many of her colleagues, their favorite

memory of her will be when she typed her stories on muggy summer days in a slip and her signature hat.

Richard W. Reading died on December 9, 1952. In November 1939, Reading lost his bid for a second term as mayor to Edward Jeffries Jr., son of the venerable judge who held Rose and Bill Veres over for trial in September 1931. He paid more than $10,000 in fines and $18,200 in civic liabilities to settle his graft case.

BIBLIOGRAPHY

Baker, David V. *Women and Capital Punishment in the United States: An Analytical History*. Jefferson, NC: McFarland, 2015.

Beynon, Erdmann Duane, *Occupational Adjustment of Hungarian Immigrants in an American Urban Community*. Ann Arbor: University of Michigan, 1937.

Burnstein, Scott M. *Motor City Mafia: A Century of Organized Crime in Detroit*. Charleston, SC: Arcadia Publishing, 2006.

Chardavoyne, David G., and Paul Moreno. *Michigan Supreme Court Historical Reference Guide*. East Lansing: Michigan State University Press, 2015.

Cohen, Irwin J. *Echoes of Detroit's Jewish Communities: A History*. N.p.: Boreal Press, 2003.

———. *Jewish Detroit*. Charleston, SC: Arcadia Publishing, 2001.

Gavrilovich, Peter, and Bill McGraw, eds. *The Detroit Almanac: 300 Year of Life in the Motor City*. Detroit, MI: Detroit Free Press, 2000.

Hauk-Abonyi, Malvina, and Mary Horwath-Monrreal. *Touring Ethnic Delray*. Ann Arbor: Southeast Michigan Regional Ethnic Heritage Studies Center, 1975.

Henrickson, Wilma Wood, ed. *Detroit Perspectives: Crossroads and Turning Points*. Detroit, MI: Wayne State University, 1991.

Holli, Melvin G., ed. *Detroit*. New Viewpoints, 1976.

Huseby-Darvas, Eva V. *Hungarians in Michigan*. East Lansing: Michigan State University Press, 2003.

Kenney, David M. *Freedom from Fear: The American People in Depression and War, 1929–1945*. Reprint, New York: Oxford University Press, 2001.

Lorence, James L. *Organizing the Unemployed: Community and Union Activists in the Industrial Heartland*. Albany: State University of New York Press, 1996.

Manning Thomas, June, ed. *Mapping Detroit: Land, Community and Shaping a City*. Detroit, MI: Wayne State University Press, 2015.

Poremba, David Lee. *Detroit: A Motor City History*. Detroit, MI: Wayne State University Press, 2001.

Rips, Rae Elizabeth, ed. *Detroit in Its World Setting*. Detroit, MI: Detroit Public Library, 1953.

Rubenstein, Bruce A., and Lawrence E. Ziewacz. *Michigan: A History of the Great Lakes State*. Fourth edition. Wheeling, IL: Harland Davidson Inc., 2008.

———. *Payoffs in the Cloakroom: The Greening of the Michigan Legislature, 1938–1946*. East Lansing: Michigan State University Press, 1995.

Scigliano, Robert G. *The Michigan One-Man Grand Jury*. East Lansing: Government Research Bureau, Michigan State University, 1957.

INDEX

ABOUT THE AUTHOR

 Karen Dybis, a former *Detroit News* reporter and longtime Metro Detroit freelance writer, is the author of *The Ford-Wyoming Drive-In: Cars, Candy and Canoodling in the Motor City* and *Better Made in Michigan: The Salty Story of Detroit's Best Chip*.

Visit us at
www.historypress.net
...
This title is also available as an e-book